AMERICA'S NATIONAL PARKS

Publications International, Ltd.

Contributing writers: David Lewis, Eric Peterson, Jennifer Pocock

Additional writers: John Boslough, John Gattuso, John A. Murray

Fact checker: Kathryn L. Holcomb

Images taken from Alamy, Corbis, Getty, The Image Works, Library of Congress, Media Bakery, NPS, Shutterstock.com, SuperStock, and USGS

Louis Weber, CEO
Publications International, Ltd.
8140 Lehigh Avenue
Morton Grove, IL 60053

Permission is never granted for commercial purposes.

ISBN: 978-1-64030-152-8

Manufactured in China.

8 7 6 5 4 3 2 1

CONTENTS

INTRODUCTION

Anyone who has explored the United States by visiting its national parks has a sense of the diversity of that beauty as it's found in the 50 states—as well as in the Virgin Islands, American Samoa, and other U.S. possessions. When people visit a national park, they walk in the footsteps of Teddy Roosevelt and John Muir; Mormon pioneers and Herbert Hoover; fur trappers and gold-crazed '49ers; dinosaurs and Native Americans; Spanish explorers and the pirate Black Caesar. Visitors see the archaeological record and living traces of landforms and animals as diverse as baked deserts and pristine coral reefs; bison and manatees; soaring mountain peaks and otherworldly caverns; natural rock staircases and limestone hoodoos. The national parks are as extraordinary as the land and people that make up America. With each passing year, as Americans better understand the impact they have on the environment, they become more aware of the inestimable value of this important national resource.

The establishment of Yellowstone as the first national park in March 1872 marked the beginning of a new attitude toward wilderness. Until that time, most Americans had thought of the nation's virgin forests, vast expanses of prairie, pristine waterways, incredibly rich mineral deposits, and other natural assets as sources of personal wealth to be used in whichever ways any individual who owned them wanted. But the astounding natural wonders of Yellowstone were catalysts that helped change the prevailing American attitude about wilderness from a desire to exploit into a wish to protect.

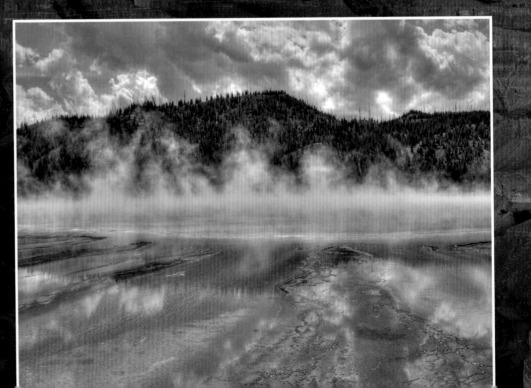

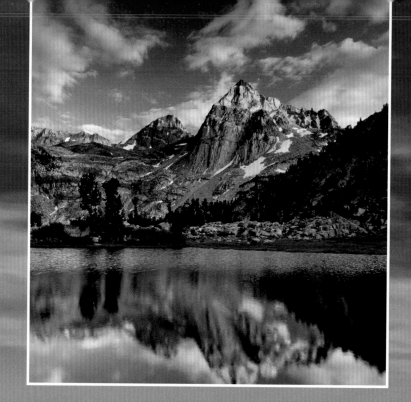

In the West, John Muir, a self-taught naturalist and cofounder of the Sierra Club, championed the cause of wilderness with great passion. Wandering the great mountain ranges of the West, particularly his beloved Sierra Nevada, Muir developed a vision of wilderness as an ecological and spiritual necessity. A persuasive writer, Muir quickly became the voice of the conservation movement.

In 1890, after much campaigning and cajoling, Congress authorized Sequoia, General Grant (later incorporated into Kings Canyon), and Yosemite national parks in California. Several years later, Mount Rainier in Washington was added to the list. Then, in 1901, Muir and his fellow conservationists found a powerful ally in President Theodore Roosevelt. An avid outdoorsman and a firm believer in the goals of the conservation movement, Roosevelt added more than 130 million acres to the national forests, launched a system of wildlife refuges, and created 18 national parks and monuments, including Petrified Forest, Mesa Verde, and Devils Tower.

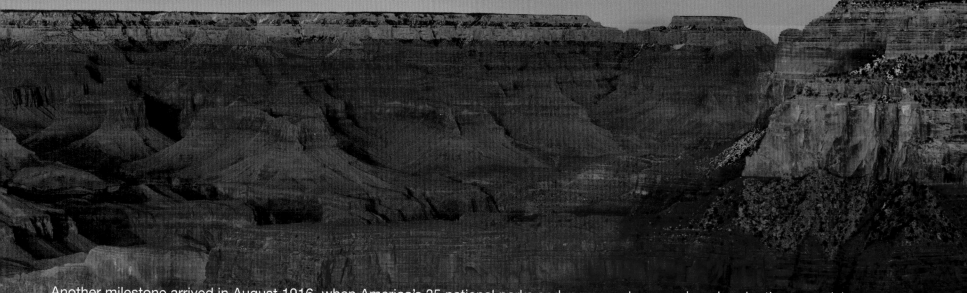

Another milestone arrived in August 1916, when America's 35 national parks and monuments were placed under the supervision of the newly created National Park Service, with a mission to "to conserve the scenery and the natural and historic objects and the wild life therein and to provide for the enjoyment of the same in such manner and by such means as will leave them unimpaired for the enjoyment of future generations."

Today, there are almost 60 national parks, protecting almost 52 million acres of land. It's estimated that more than 300 million people visited a national park in 2015!

ACADIA
NATIONAL PARK

Coast of Maine
Established January 19, 1929,
the earliest national park east of the Mississippi
74 square miles

Things to See: *Cadillac Mountain; Mount Desert; Islesford Historical Museum; Wild Gardens of Acadia*

Things to Do: *Hiking; Fishing; Climbing; Bird-watching; Swimming; Boating; Horseback riding; Bicycling; Leaf peeping*

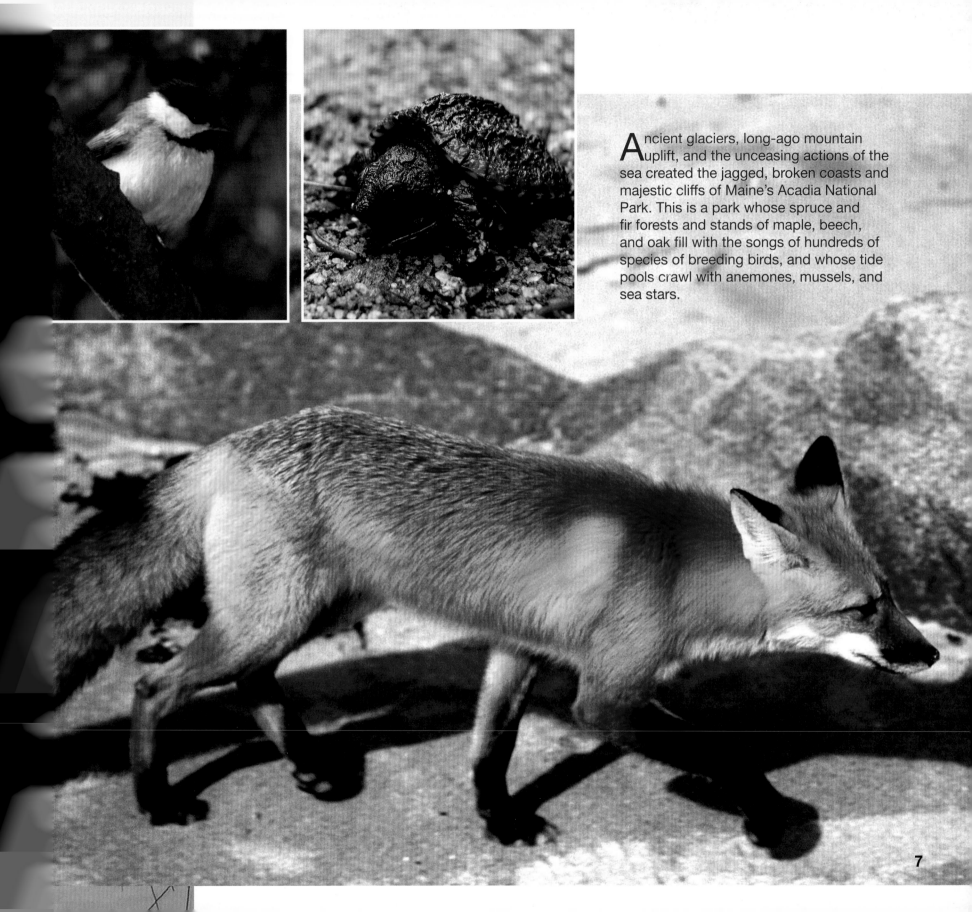

Ancient glaciers, long-ago mountain uplift, and the unceasing actions of the sea created the jagged, broken coasts and majestic cliffs of Maine's Acadia National Park. This is a park whose spruce and fir forests and stands of maple, beech, and oak fill with the songs of hundreds of species of breeding birds, and whose tide pools crawl with anemones, mussels, and sea stars.

The creation of national parks in the East was notoriously difficult. Back in the days of Teddy Roosevelt, the West was still, for the most part, wide open and almost unfathomably large.

In the eastern United States, however, much of the land was already private, owned by logging companies or investors. Private owners didn't want to give up their pristine locations, and the loggers were even more stubborn. Proposing that they set aside stands of large, old-growth trees that could otherwise make them a nice profit would generally earn a hearty laugh in return. In addition, many politicians of the time largely agreed—taking over potentially profitable land just for the sake of scenery was ridiculous.

How, then, were parks supposed to thrive when it seemed everyone was against them? Two words: star power.

Many rich and powerful people of the late 1800s were discovering the appeal of getting away from the hubbub of everyday life and communing with nature. Today's Acadia National Park was originally a retreat for the wealthiest New York elite. It was a Harvard president named Charles W. Eliot, however, who started the bid for parkdom in 1898 after the death of his son, who dearly loved the lands. Eliot encouraged others who longed to see the lands preserved to organize a group of trustees who worked tirelessly to petition for a bill creating the park and to raise money and land donations for parklands.

One trustee, George B. Dorr, organized the donation of 5,000 acres. This became the national monument that was signed into existence by Woodrow Wilson in 1919. A decade later, the park's name was changed to Acadia.

NATIONAL PARK OF AMERICAN SAMOA

Samoa is a dazzling chain of jewel-like islands twinkling across a lonely expanse of the South Pacific. Four of its easternmost islands and two coral reefs comprise the National Park of American Samoa. Formed by volcanic activity originating on the ocean floor, the islands are a tropical paradise of mountains, rain forests, deep harbors, and stunning white beaches.

Established October 31, 1988
21 square miles
More than 2,500 acres of the park lies under water!

Things to See: *Lata Mountain; Mount Alava Trail; Tufu Point*

Things to Do: *Snorkeling and swimming; Hiking and beachwalking; Sightseeing*

For about 3,000 years, members of Polynesia's oldest culture have lived on these islands. Samoa means "sacred earth," the name reflecting the belief of the people that the islands are a special place to be cherished and protected. This is also the basis for the park, which provides some protection to the ancient culture there.

9

ARCHES NATIONAL PARK

Chiseled by the powerful, perpetual forces of wind and water, this surprising natural rock garden contains the planet's most remarkable collection of abstract sculpture. Arches National Park sits on a great plateau in southeastern Utah, encompassing a stark landscape of broken red sandstone. The park contains more than 2,000 natural stone arches. But these spectacular sandstone portals, braced against the desert sky and revealing lovely desert terrain through their openings, are only part of the stunning landscape here.

Southeastern Utah
Established November 12, 1971
120 square miles

Things to See: *Delicate Arch; Fiery Furnace; Wolfe Ranch; Balanced Rock; Double Arch*

Things to Do: *Hiking; Backpacking; Camping; Climbing; Biking*

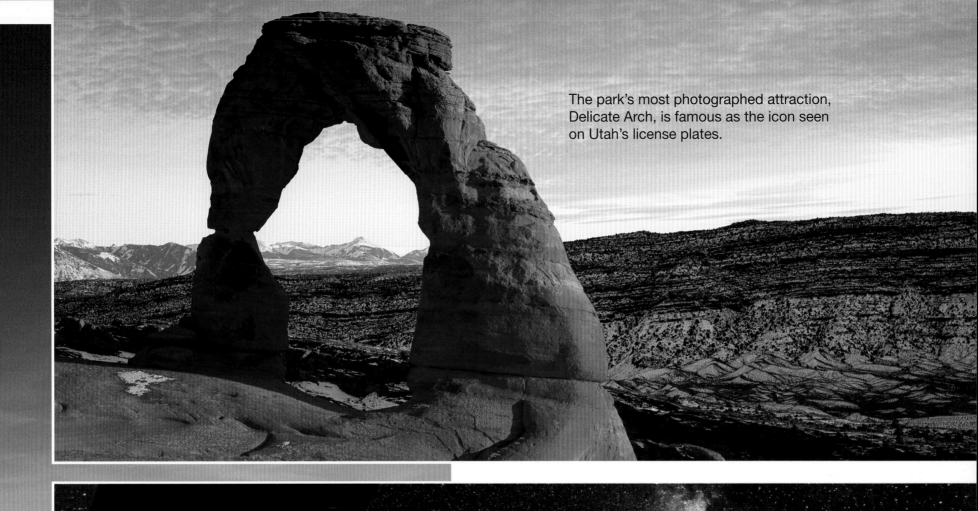

The park's most photographed attraction, Delicate Arch, is famous as the icon seen on Utah's license plates.

NIGHT SKY

Most of the mammals that live in Arches are nocturnal, including kangaroo rats, skunks, foxes, and bats. Other animals in the park are crepuscular, meaning they are active at dawn and dusk. Arches' crepuscular animals include jackrabbits, songbirds, coyotes, and mule deer.

BADLANDS NATIONAL PARK

Southwestern South Dakota
Established November 10, 1978
380 square miles

Things to See: *Big Pig Dig; Robert's Prairie Dog Town; the Wall; the Castle Trail*

Things to Do: *Hiking; Camping; Studying fossils*

The stark, uninviting terrain of the Badlands has been called a masterpiece of natural sculpture, of wind and rain that carves uncanny shapes, revealing colored bands in stratified layers. Rain comes rarely, washing away an average of an inch of sediment annually in South Dakota's White River Badlands. Some observers say one thunderstorm can create perceptible changes in the Badlands landscape, and this process has been going on for about 75 million years.

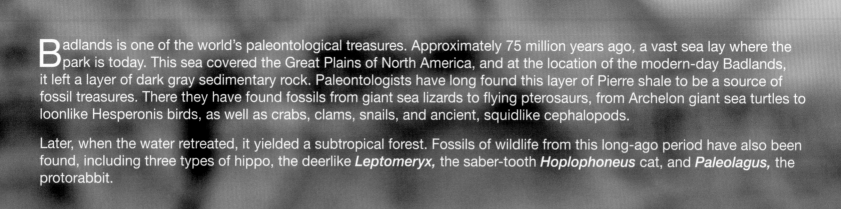

adlands is one of the world's paleontological treasures. Approximately 75 million years ago, a vast sea lay where the park is today. This sea covered the Great Plains of North America, and at the location of the modern-day Badlands, it left a layer of dark gray sedimentary rock. Paleontologists have long found this layer of Pierre shale to be a source of fossil treasures. There they have found fossils from giant sea lizards to flying pterosaurs, from Archelon giant sea turtles to loonlike Hesperonis birds, as well as crabs, clams, snails, and ancient, squidlike cephalopods.

Later, when the water retreated, it yielded a subtropical forest. Fossils of wildlife from this long-ago period have also been found, including three types of hippo, the deerlike *Leptomeryx,* the saber-tooth *Hoplophoneus* cat, and *Paleolagus,* the protorabbit.

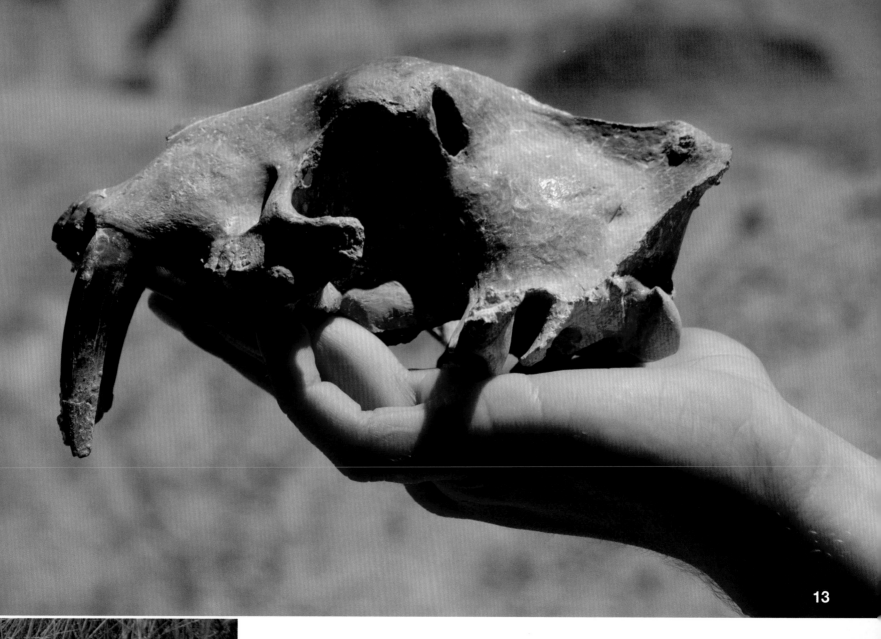

Badlands National Park's bison herd now numbers well above 1,000.

14

BIG BEND NATIONAL PARK

Southwestern Texas
Established June 12, 1944
,250 square miles

Things to See: *Santa Elena Canyon; Castolon Historic District; Sotol Vista; Sam Nail Ranch; Window View Trail; Mule Ears Overlook; Homer Wilson Ranch; Tuff Canyon*

Things to Do: *Hiking; Camping; Rafting; Backpacking; Climbing; Bicycling; Birding*

More than 800,000 acres in all, Big Bend National Park encompasses a seemingly endless expanse of forested mountains, impossibly sheer canyons, and rugged desert wilderness just across the Rio Grande from Mexico in West Texas. Here the ver winds south then suddenly veers north in a great horseshoe curve before turning outhward again, thus the moniker, Big Bend.

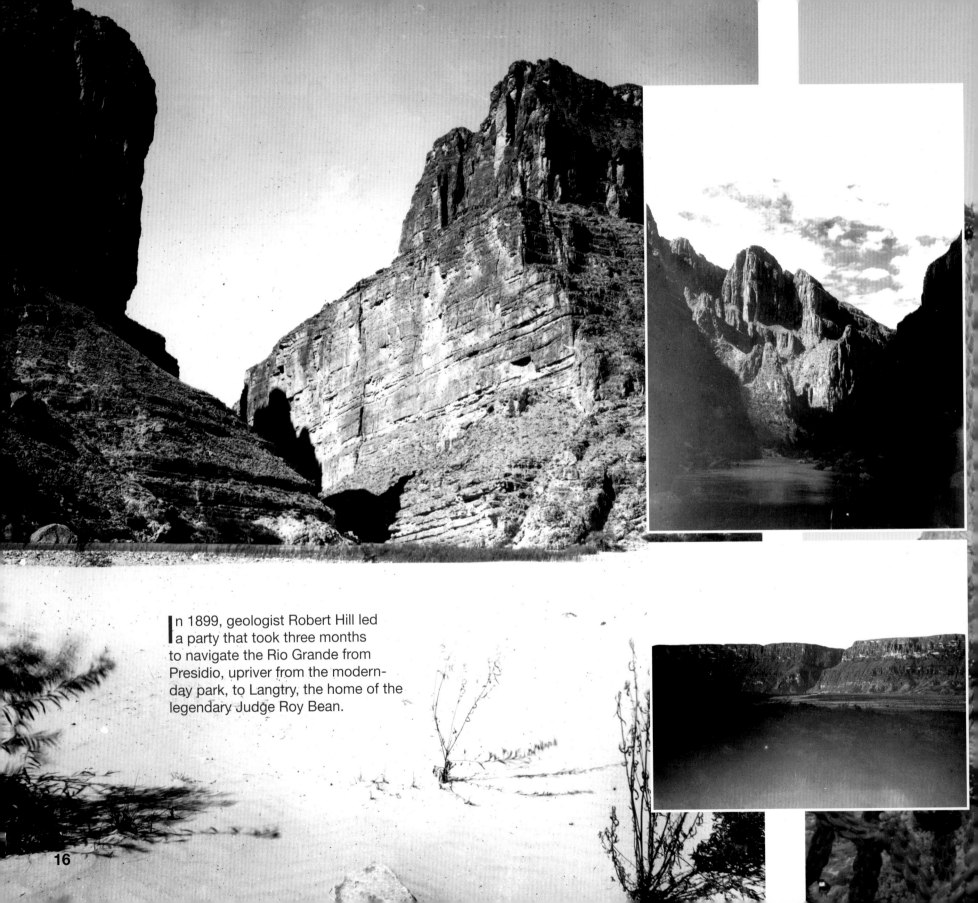

In 1899, geologist Robert Hill led a party that took three months to navigate the Rio Grande from Presidio, upriver from the modern-day park, to Langtry, the home of the legendary Judge Roy Bean.

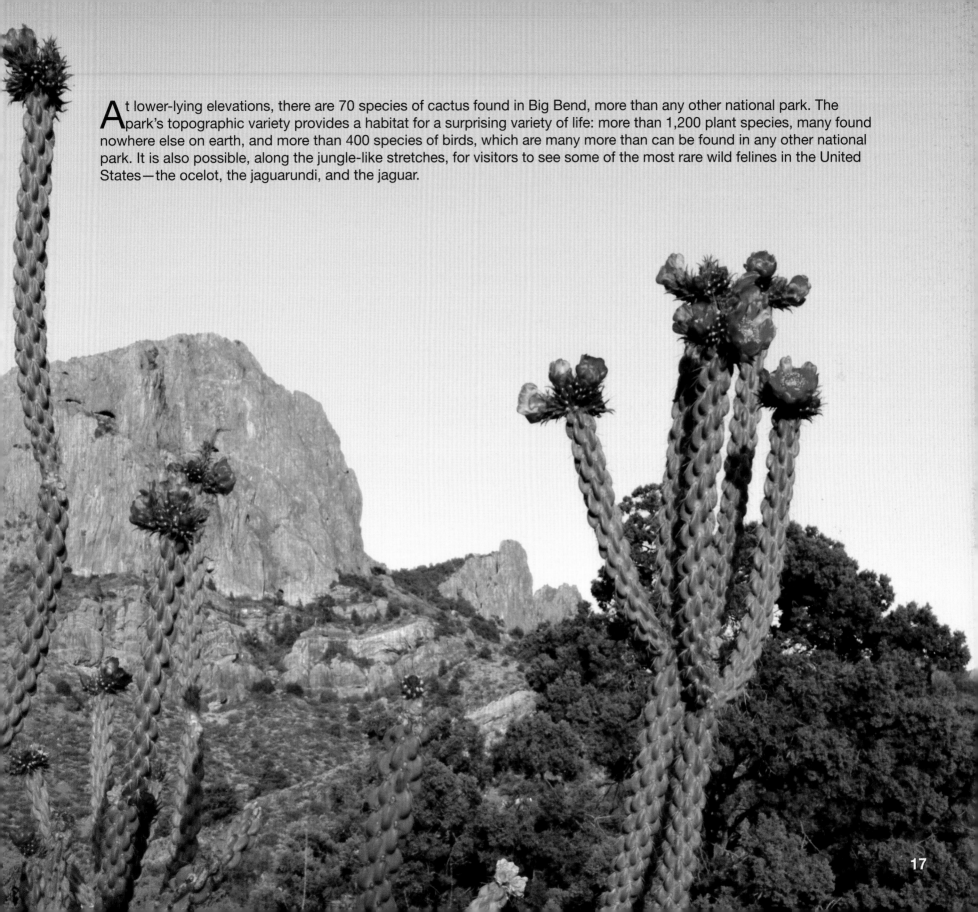

At lower-lying elevations, there are 70 species of cactus found in Big Bend, more than any other national park. The park's topographic variety provides a habitat for a surprising variety of life: more than 1,200 plant species, many found nowhere else on earth, and more than 400 species of birds, which are many more than can be found in any other national park. It is also possible, along the jungle-like stretches, for visitors to see some of the most rare wild felines in the United States—the ocelot, the jaguarundi, and the jaguar.

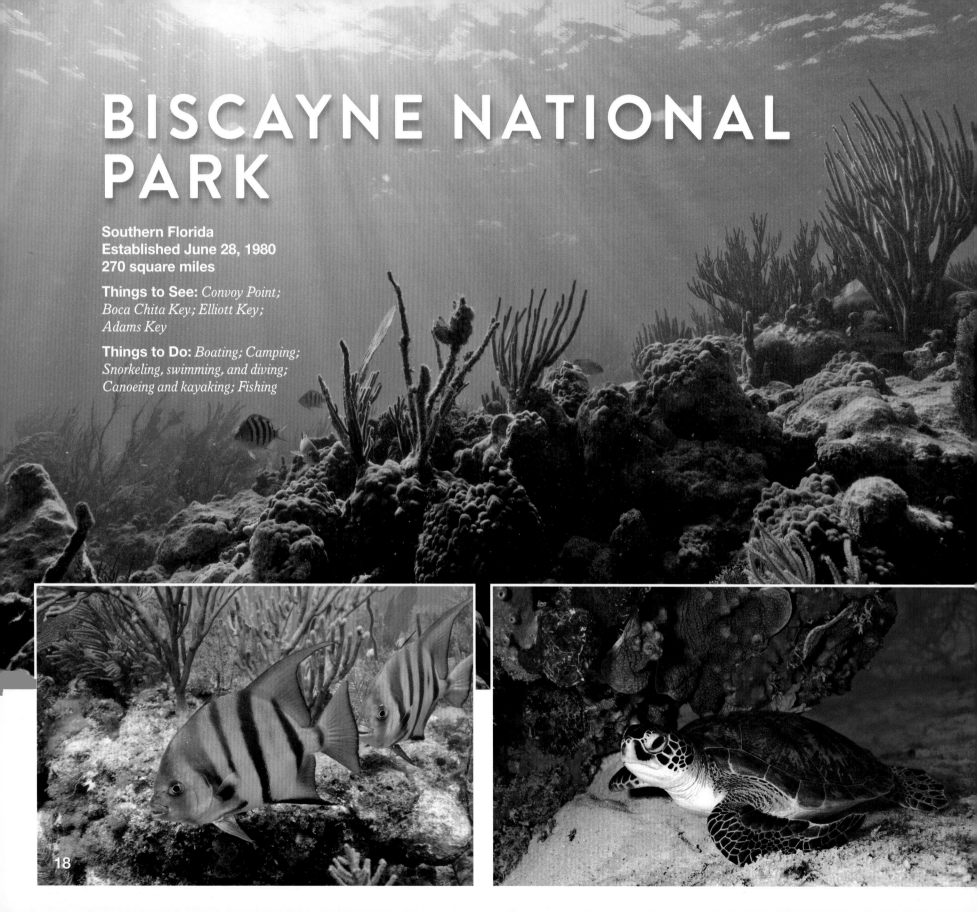

BISCAYNE NATIONAL PARK

Southern Florida
Established June 28, 1980
270 square miles

Things to See: *Convoy Point;*
Boca Chita Key; Elliott Key;
Adams Key

Things to Do: *Boating; Camping;*
Snorkeling, swimming, and diving;
Canoeing and kayaking; Fishing

The area that is now Biscayne National Park was once home to one of the most fearsome pirates to roam the high seas. In the mid-to-late 1600s, Black Caesar was a mighty leader in Haiti. The legend goes that he and his followers were tricked on board a boat visiting his shores with promises of treasure. While the boat's crew entertained Black Caesar and his crew with music, dancing, and rare jewels, the boat quietly cast off, leaving them trapped on board. Subsequently, they were locked in the hold, destined for slavery in the Americas. His crew fought for freedom, trying to overtake the slavers—but it was a battle that the Haitians ultimately lost.

While on the sea, however, the slaver's ship ran into a hurricane near Biscayne Bay. With the help of a friend (some accounts say that he was a crew member who took pity on him), Black Caesar escaped in a long boat with a few supplies while most of the other men perished. When the storm cleared, the ship had been washed ashore and smashed by the reef and high winds. With his friend, the downed ship, and the longboat, Black Caesar devised a plan: Whenever a ship passed by, Caesar and his crew floated in the longboat near their wreckage, pretending to be victims of a shipwreck. When the new ships took them aboard, the brigands would attack, taking the treasure captive and, sometimes, the ship and crew, as well. The name of Black Caesar came to be feared among those who sailed near Florida's coast, and the base of his operations is still known as Black Caesar's Rock.

BLACK CANYON OF THE GUNNISON NATIONAL PARK

Western Colorado
Established October 21, 1999
50 square miles

Things to See: *Gunnison Point; Painted Wall; Chasm View; Dragon Point*

Things to Do: *Hiking; Rafting; Rock climbing; Kayaking; Camping; Horseback riding*

Starting at its headwaters high in the central Rocky Mountains of Colorado, the hypnotically blue Gunnison River flows for nearly 100 miles through the rolling sage-and aspen-covered scenery before entering one of the most spectacular gorges in North America—the Black Canyon of the Gunnison River.

This canyon is dramatic and impossibly steep, crafted by the river in grand fashion. At its deepest, the Black Canyon is 2,722 feet from river to rim. The Black in Black Canyon comes from the fact that, at the canyon's deepest points, sunlight only reaches the bottom for an hour a day. Varying heights and depths in the canyon mean extremes in temperature. The canyon has some of the coldest recorded temperatures at its latitude, dropping to -40 degrees Fahrenheit during the winter.

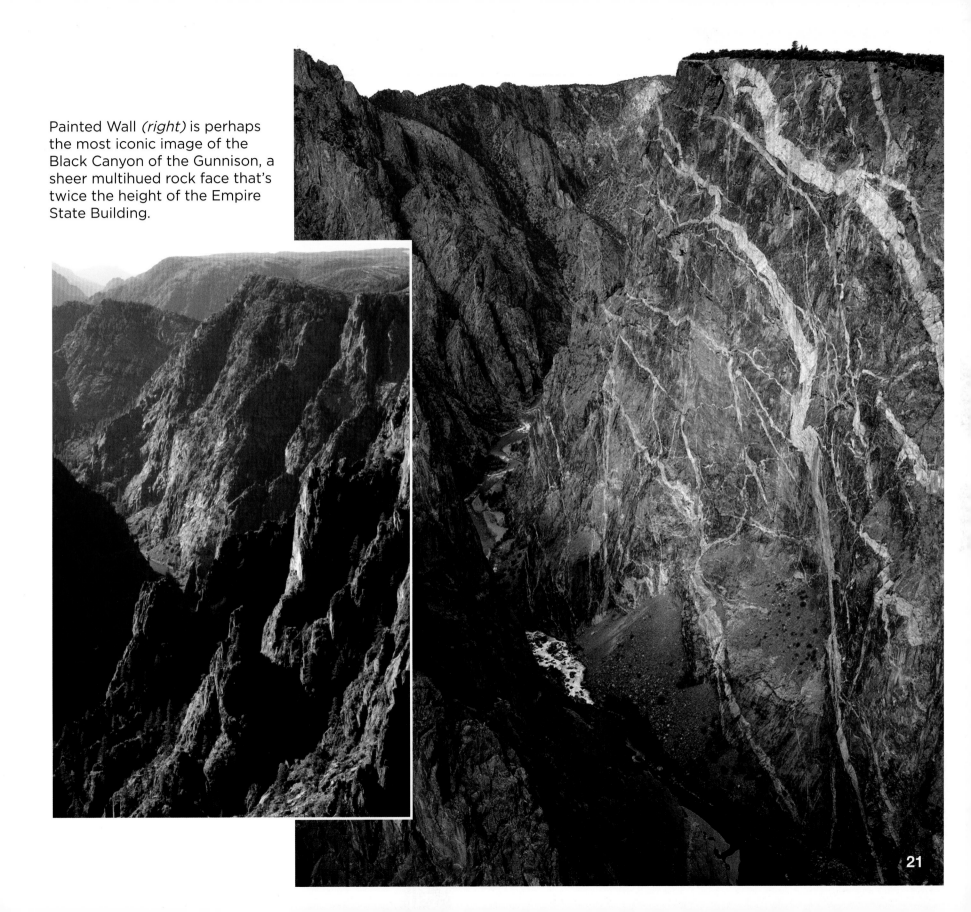

Painted Wall *(right)* is perhaps the most iconic image of the Black Canyon of the Gunnison, a sheer multihued rock face that's twice the height of the Empire State Building.

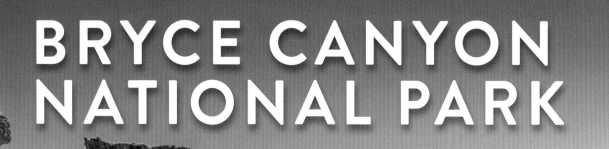

BRYCE CANYON NATIONAL PARK

Southwestern Utah
Established September 15, 1928
56 square miles

Things to See: *Inspiration Point; Thor's Hammer; Riggs Spring Loop; Bryce Point; Wall Street Trail; Paunsaugunt Plateau; Sunrise Point; Paria View*

Things to Do: *Hiking; Horseback or muleback riding; Cross-country skiing in winter; Snowshoe hikes in winter*

A maelstrom of rock figures of every size, shape, and color, sculpted by the elements over millions of years, Bryce Canyon National Park is one of the most amazing landscapes nature has to offer. The Bryce escarpment, with its thousands of geological gargoyles and castellated spires, is the product of the relentless strength of water and time.

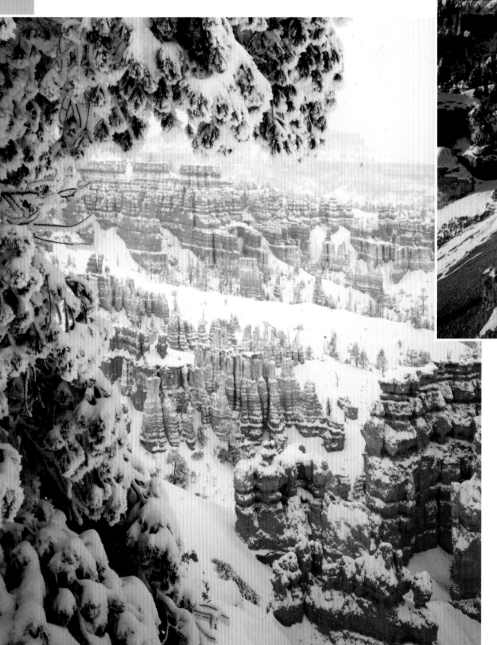

This hypnotic and otherworldly landscape looks as if it has been gouged free of earth and then filled with hoodoos, orange and red rock pedestals of all descriptions. These endless rock towers take on all kinds of shapes (resembling castles, bridges, towers, presidents, prime ministers, Thor's hammer, and even Queen Victoria) and sizes (ranging from human-size to more than 100 feet tall).

CANYONLANDS NATIONAL PARK

Southeastern Utah
Established September 12, 1964
525 square miles

Things to See: *Islands in the Sky; the Needles; the Maze; Chesler Park; Green River; Devil's Kitchen; Horseshoe Canyon; Colorado River; Butler Flat; Peekaboo Spring; Cataract Canyon*

Things to Do: *Hiking; Boating; Backpacking; Horseback riding; Climbing; Biking; Camping*

The wild array of arches, sandstone pillars and needles, canyon mazes, and scarps that make up the otherworldly terrain of Canyonlands is the work of the Colorado and Green rivers. They meet in the heart of the park at a spectacular site called the Confluence. There the rivers form a great Y, cutting 1,000 feet into the brilliantly hued sandstone. From the Confluence, the rivers

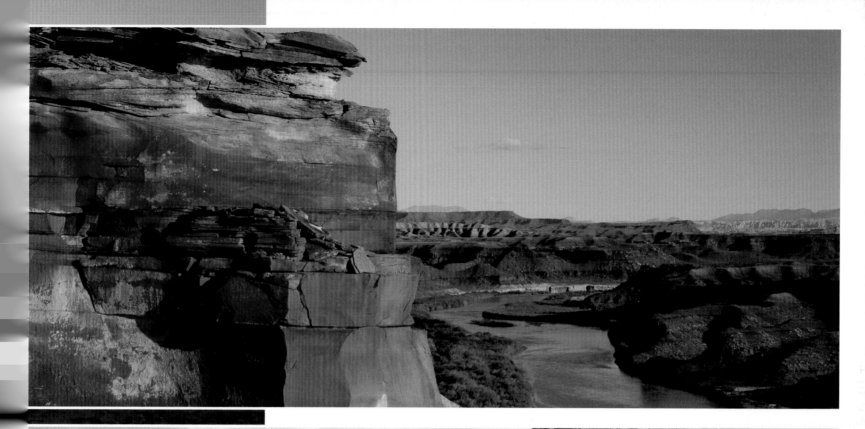

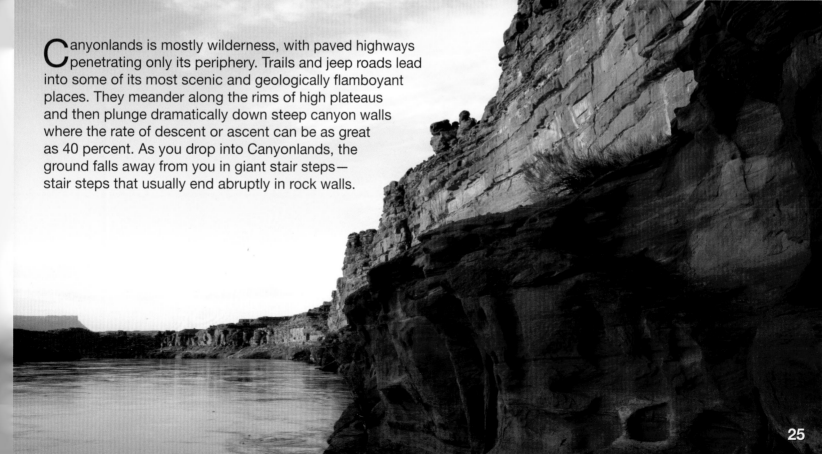

Canyonlands is mostly wilderness, with paved highways penetrating only its periphery. Trails and jeep roads lead into some of its most scenic and geologically flamboyant places. They meander along the rims of high plateaus and then plunge dramatically down steep canyon walls where the rate of descent or ascent can be as great as 40 percent. As you drop into Canyonlands, the ground falls away from you in giant stair steps— stair steps that usually end abruptly in rock walls.

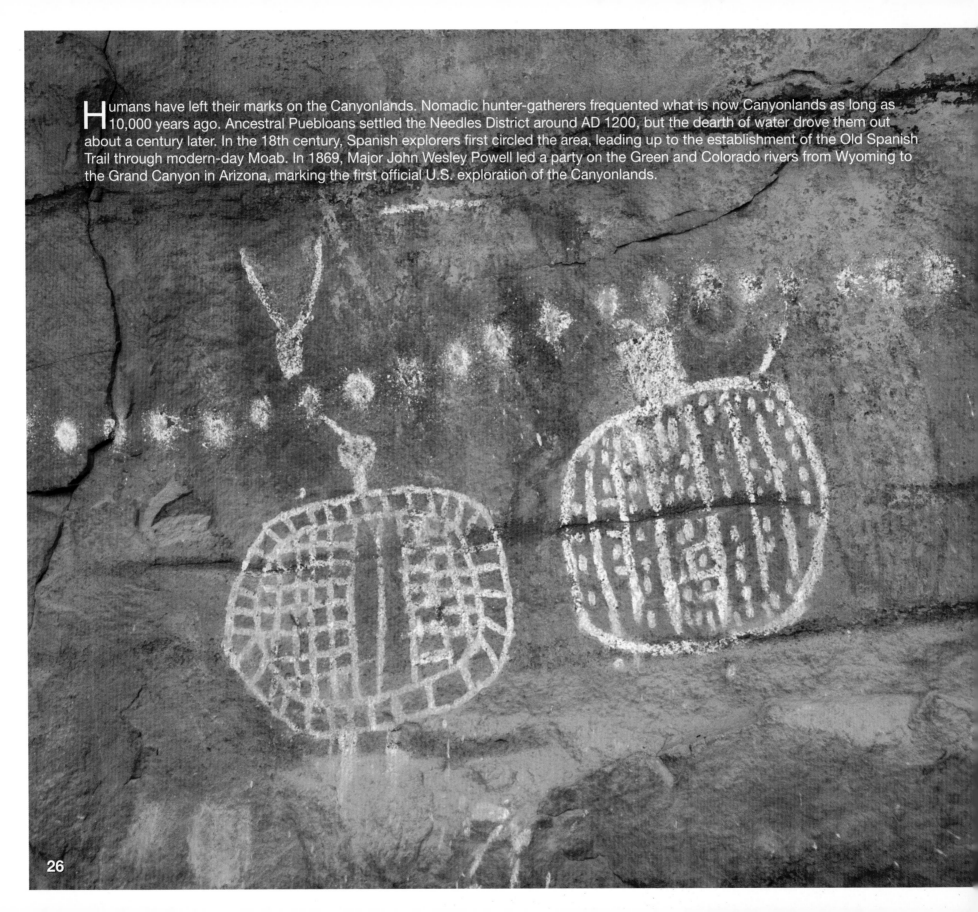

Humans have left their marks on the Canyonlands. Nomadic hunter-gatherers frequented what is now Canyonlands as long as 10,000 years ago. Ancestral Puebloans settled the Needles District around AD 1200, but the dearth of water drove them out about a century later. In the 18th century, Spanish explorers first circled the area, leading up to the establishment of the Old Spanish Trail through modern-day Moab. In 1869, Major John Wesley Powell led a party on the Green and Colorado rivers from Wyoming to the Grand Canyon in Arizona, marking the first official U.S. exploration of the Canyonlands.

CAPITOL REEF NATIONAL PARK

Southern Utah
Established December 18, 1971
375 square miles

Things to See: *Cathedral Valley; Freemont River; Temple of the Sun Rock Formation; Waterpocket Fold; Behunin Cabin; Historic Gifford Homestead; Fruita Rural Historic District*

Things to Do: *Camping; Hiking; Backpacking; Rock climbing; Horseback riding; Fishing*

In the 19th century, Mormon pioneers farmed and planted orchards in the valley, leaving behind the roughly 2,600 apple, peach, and apricot trees that are still there to this day. Modern park visitors can even pick fruit during harvest season for a nominal fee.

Waterpocket Fold, of which Capitol Reef is a segment, is an immense pleat in the earth's crust that rises in great parallel ridges for 100 miles across the starkly beautiful desert landscape of southern Utah. The landscape of Capitol Reef National Park is defined by this dramatic warp in the earth's surface. The west side of the fold is 7,000 feet higher than the east side, thanks to a major geological event that took place about 60 million years ago.

27

CARLSBAD CAVERNS NATIONAL PARK

Southeast New Mexico
Established May 14, 1930
73 square miles

Things to See: *Bat Caves; Giant Dome; King's Palace; Big Room; Hall of the White Giant; Spider Cave; Guadalupe Mountains*

Things to Do: *Caving; Hiking; Back Country Camping; Bat viewing*

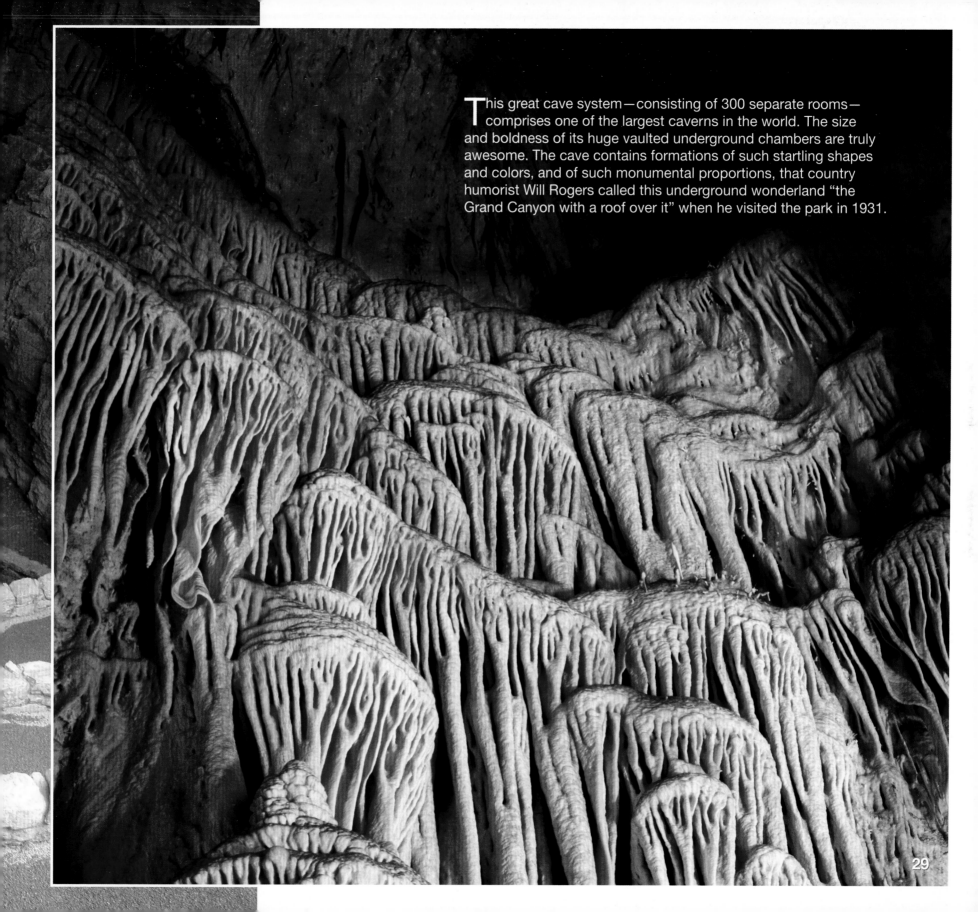

This great cave system—consisting of 300 separate rooms—comprises one of the largest caverns in the world. The size and boldness of its huge vaulted underground chambers are truly awesome. The cave contains formations of such startling shapes and colors, and of such monumental proportions, that country humorist Will Rogers called this underground wonderland "the Grand Canyon with a roof over it" when he visited the park in 1931.

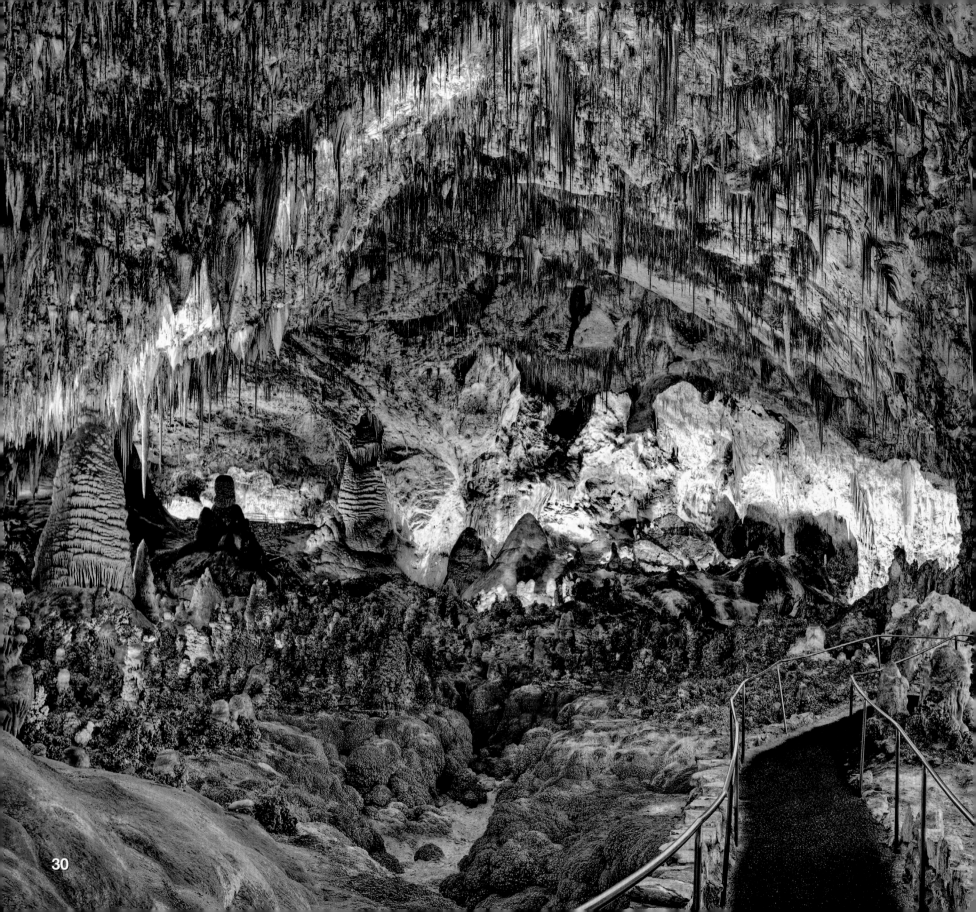

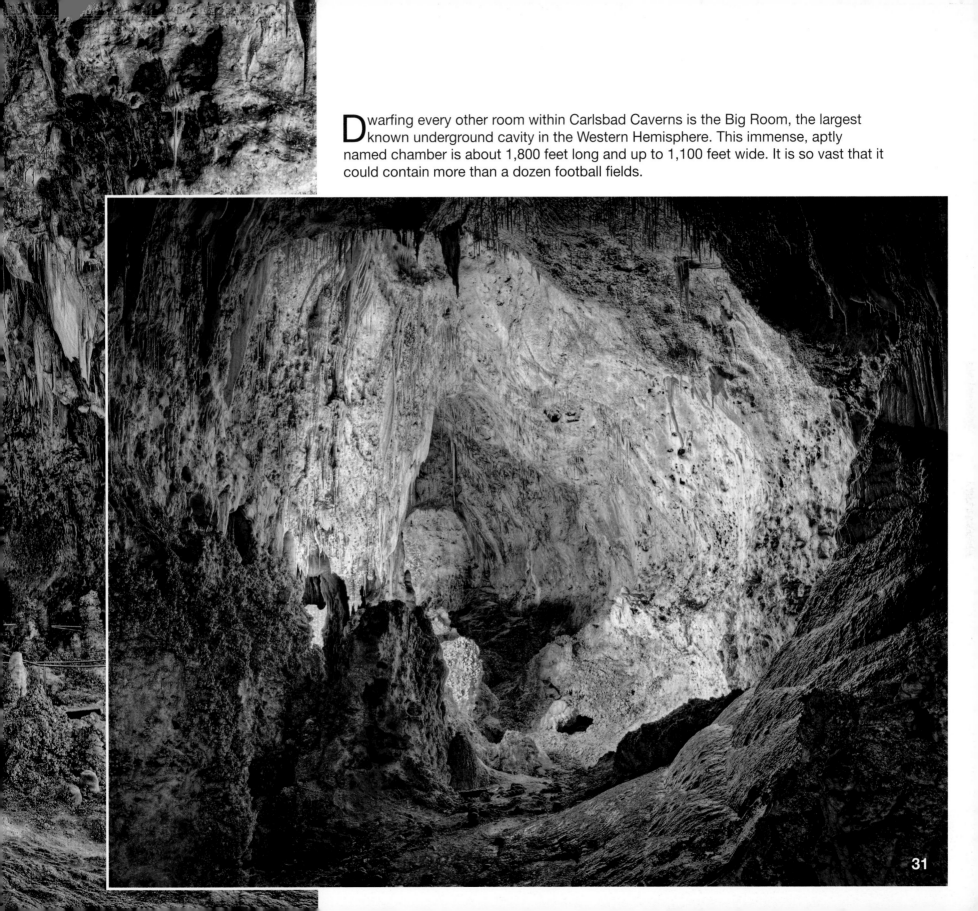

Dwarfing every other room within Carlsbad Caverns is the Big Room, the largest known underground cavity in the Western Hemisphere. This immense, aptly named chamber is about 1,800 feet long and up to 1,100 feet wide. It is so vast that it could contain more than a dozen football fields.

CHANNEL ISLANDS NATIONAL PARK

Off the Southern California coast
Established March 5, 1980
390 square miles

Things to See: *Anacapa Island; Santa Cruz Island; Santa Rosa Island; San Miguel Island; Santa Barbara Island; Arch Rock*

Things to Do: *Hiking; Snorkeling; Kayaking; Scuba diving; Boating; Camping*

Only 90 minutes by boat from the beaches of Southern California is the aptly named Arch Rock, a 40-foot semicircle jutting out of the Pacific off Anacapa Island and the de facto gateway to the Channel Islands. The national park comprises the five northernmost islands of this eight-island chain.

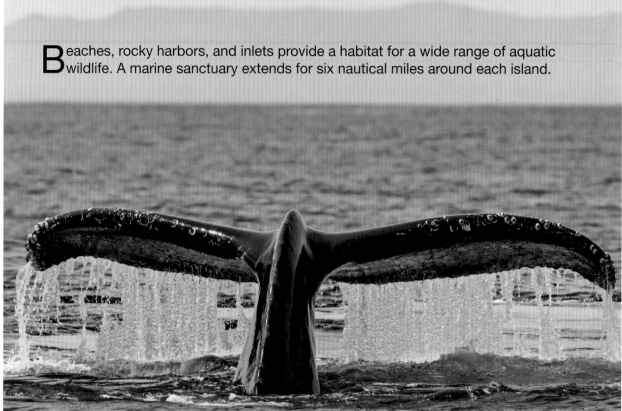

Beaches, rocky harbors, and inlets provide a habitat for a wide range of aquatic wildlife. A marine sanctuary extends for six nautical miles around each island.

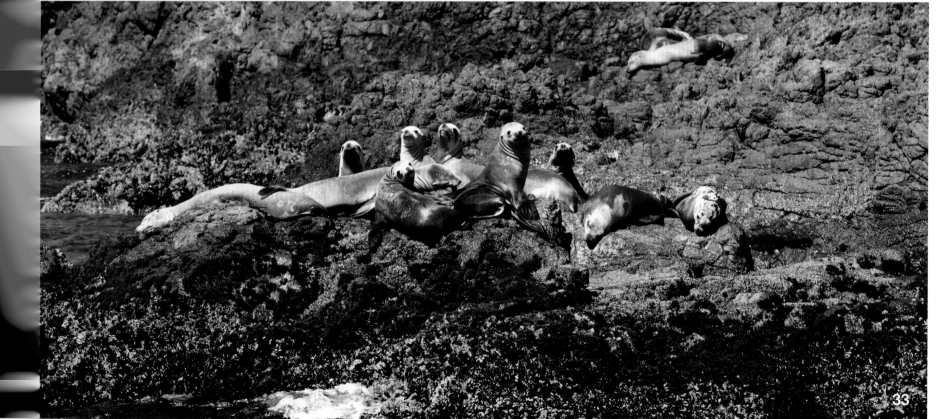

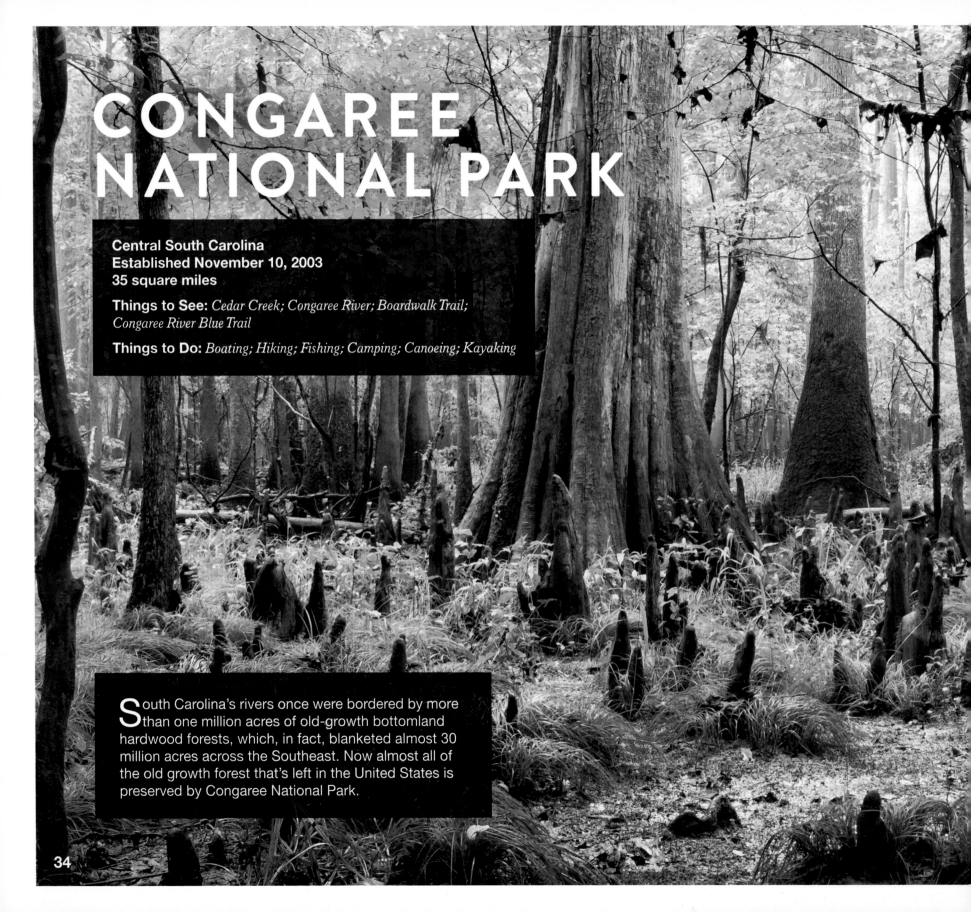

CONGAREE NATIONAL PARK

Central South Carolina
Established November 10, 2003
35 square miles

Things to See: *Cedar Creek; Congaree River; Boardwalk Trail; Congaree River Blue Trail*

Things to Do: *Boating; Hiking; Fishing; Camping; Canoeing; Kayaking*

South Carolina's rivers once were bordered by more than one million acres of old-growth bottomland hardwood forests, which, in fact, blanketed almost 30 million acres across the Southeast. Now almost all of the old growth forest that's left in the United States is preserved by Congaree National Park.

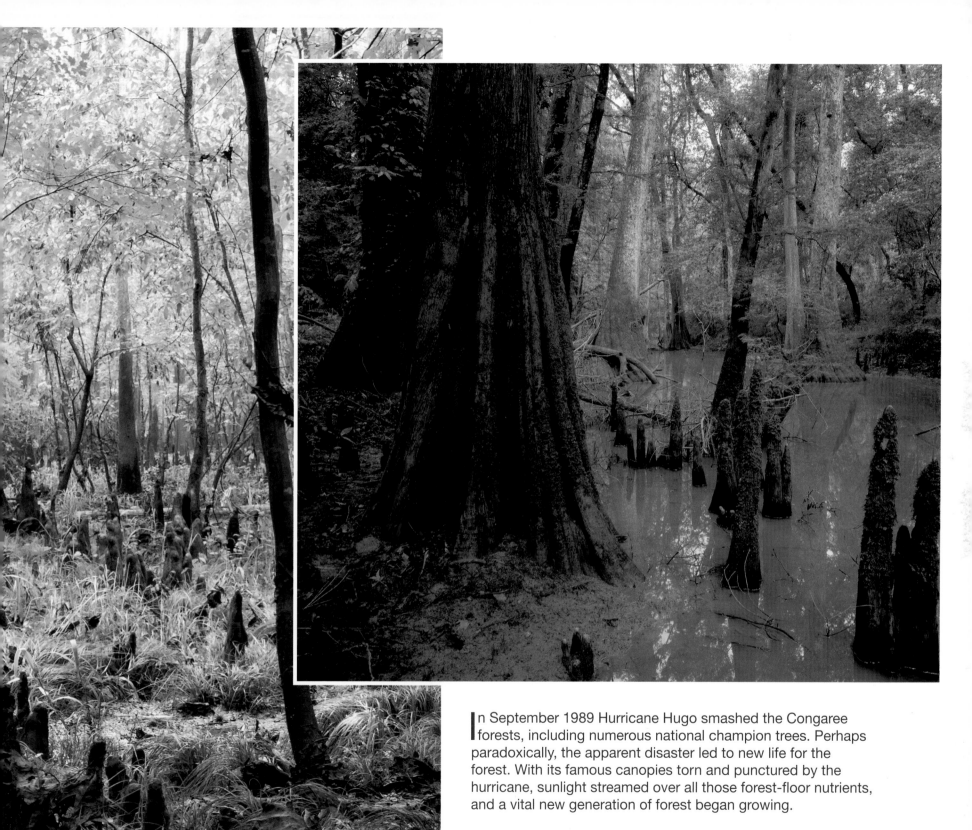

In September 1989 Hurricane Hugo smashed the Congaree forests, including numerous national champion trees. Perhaps paradoxically, the apparent disaster led to new life for the forest. With its famous canopies torn and punctured by the hurricane, sunlight streamed over all those forest-floor nutrients, and a vital new generation of forest began growing.

CRATER LAKE NATIONAL PARK

Southwestern Oregon
Established May 22, 1902
285 square miles

Things to See: *Crater Lake; Wizard Island; Phantom Ship; Mount Scott; Watchman Overlook*

Things to Do: *Hiking; Backcountry camping; Boating*

Southern Oregon's Crater Lake National Park, centered on the idyllic blue lake of its namesake, is one of the grandest sights on the continent. After approaching the lake on a road that gradually rises, twisting and turning its way up the side of a mountain clothed in forests of Shasta red fir, hemlock, and pine, the pavement plunges downward into a great basin, and there is the vast and mirrorlike surface of Crater Lake, 25 square miles of water so blue that it looks like India ink, circled by steep slopes, mountains, and great cliffs that form a vast natural amphitheater.

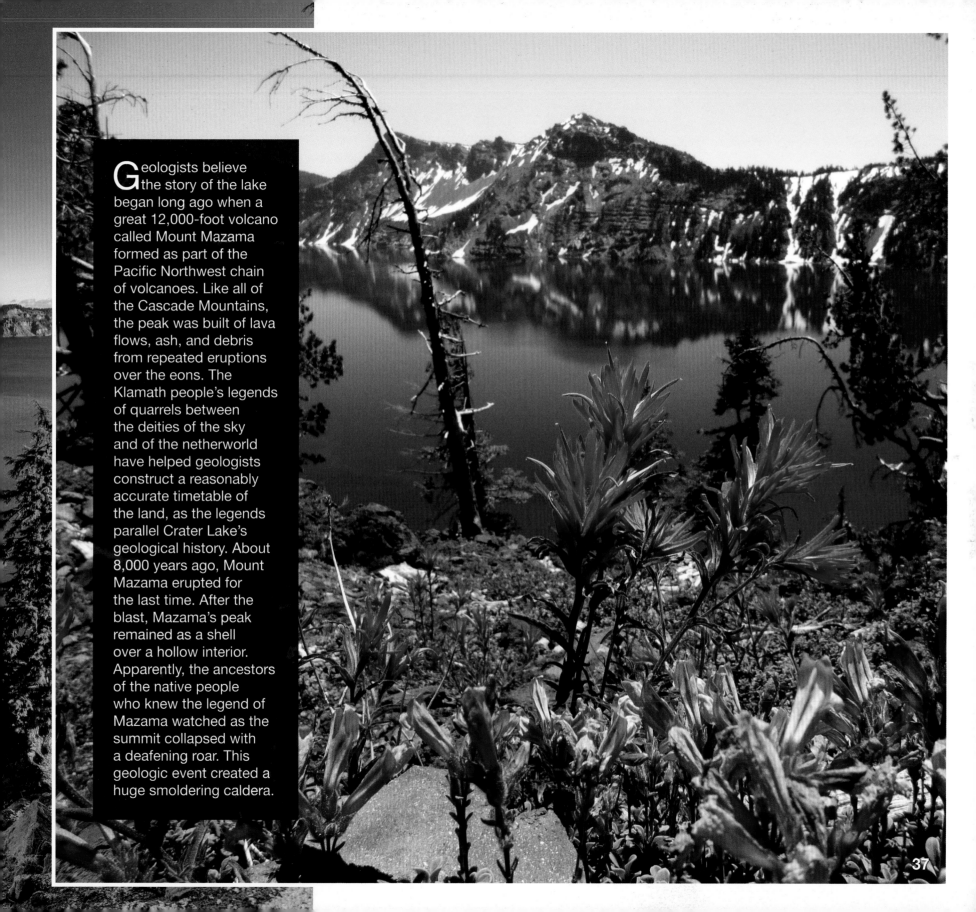

Geologists believe the story of the lake began long ago when a great 12,000-foot volcano called Mount Mazama formed as part of the Pacific Northwest chain of volcanoes. Like all of the Cascade Mountains, the peak was built of lava flows, ash, and debris from repeated eruptions over the eons. The Klamath people's legends of quarrels between the deities of the sky and of the netherworld have helped geologists construct a reasonably accurate timetable of the land, as the legends parallel Crater Lake's geological history. About 8,000 years ago, Mount Mazama erupted for the last time. After the blast, Mazama's peak remained as a shell over a hollow interior. Apparently, the ancestors of the native people who knew the legend of Mazama watched as the summit collapsed with a deafening roar. This geologic event created a huge smoldering caldera.

CUYAHOGA VALLEY NATIONAL PARK

Northeastern Ohio
Established October 11, 2000
51 square miles

Things to See: *Cuyahoga River; Ohio & Erie Canalway; Towpath Trail; Frazee House; Cuyahoga Valley Scenic Railway; Brandywine Falls; Beaver Marsh; Blue Hen Falls*

Things to Do: *Hiking; Bicycling; Canoeing; Kayaking; Picnicking; Bird-watching; Camping; Fishing; Golfing*

Traveling Cuyahoga Valley National Park, which lies in Ohio almost equidistant between Akron and Cleveland, is an adventure in the park service's most urban-friendly environment. The park preserves 33,000 acres along the Cuyahoga River. Within its bounds, Cuyahoga Valley National Park contains an astonishing array of fauna and flora, boundless varieties of forests, plains, streams and ravines, breathtaking waterfalls, and historic excursions.

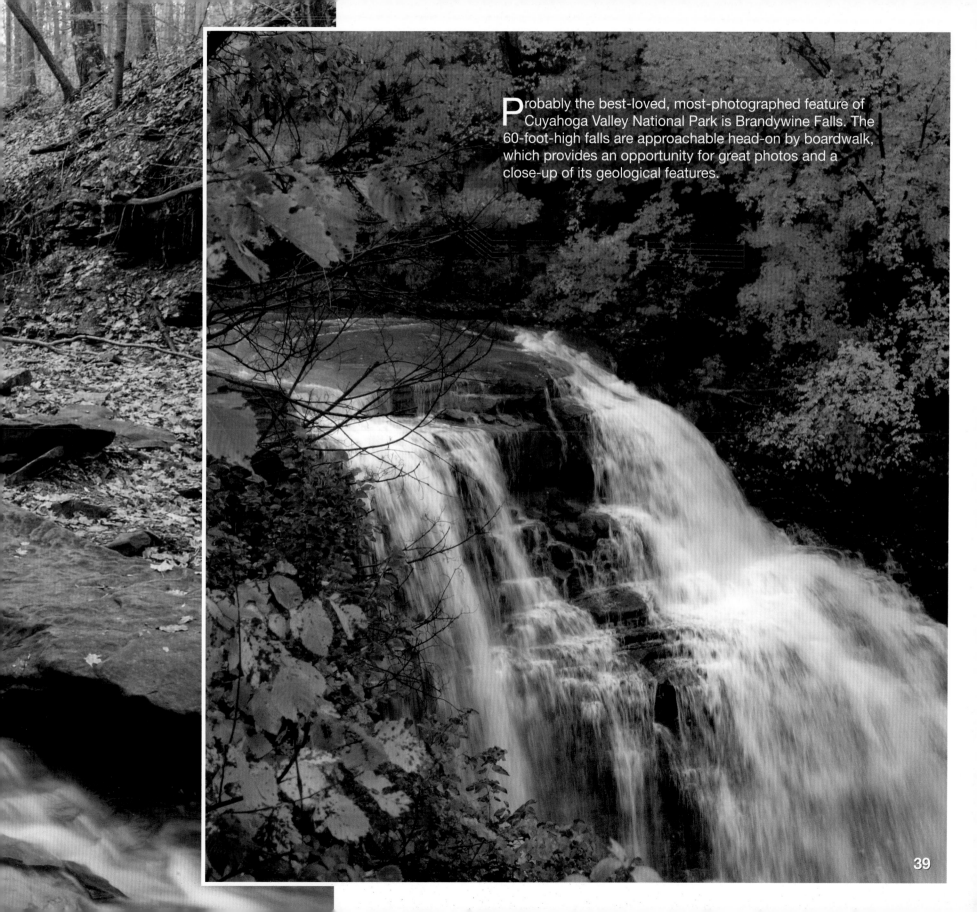

Probably the best-loved, most-photographed feature of Cuyahoga Valley National Park is Brandywine Falls. The 60-foot-high falls are approachable head-on by boardwalk, which provides an opportunity for great photos and a close-up of its geological features.

DEATH VALLEY NATIONAL PARK

East central California
Established October 31, 1994
5,270 square miles

Things to See: *Badwater Basin; Telescope Peak; Zabriskie Point; Furnace Creek; Stovepipe Wells; Scotty's Castle; Panamint Springs; Ubehebe Crater; Eureka Dunes*

Things to Do: *Hiking; Backpacking; Backcountry camping; Biking; Bird-watching*

In remote eastern California, Death Valley National Park holds the record for the highest temperature ever recorded in the Western Hemisphere: The mercury sizzled its way up to 134 degrees Fahrenheit in July 1913. Formerly a world record, that temperature was commemorated in the form of the world's tallest thermometer in the nearby town of Baker, California, but it was ultimately eclipsed by a scorcher in Libya that supposedly hit 136 degrees. But world record or not, it's still very hot here—in 2001, the daily high exceeded 100 degrees for an amazing 154 days in a row.

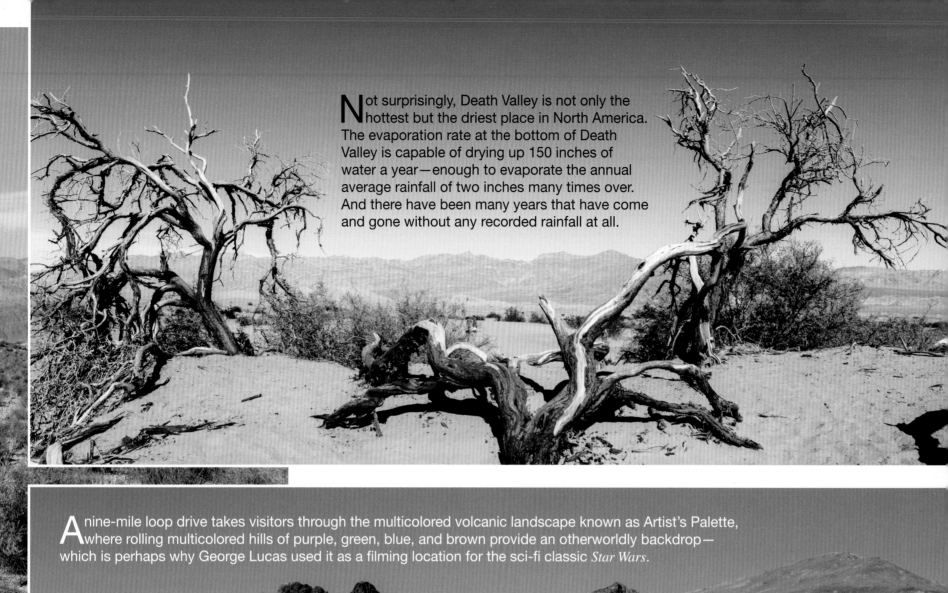

Not surprisingly, Death Valley is not only the hottest but the driest place in North America. The evaporation rate at the bottom of Death Valley is capable of drying up 150 inches of water a year—enough to evaporate the annual average rainfall of two inches many times over. And there have been many years that have come and gone without any recorded rainfall at all.

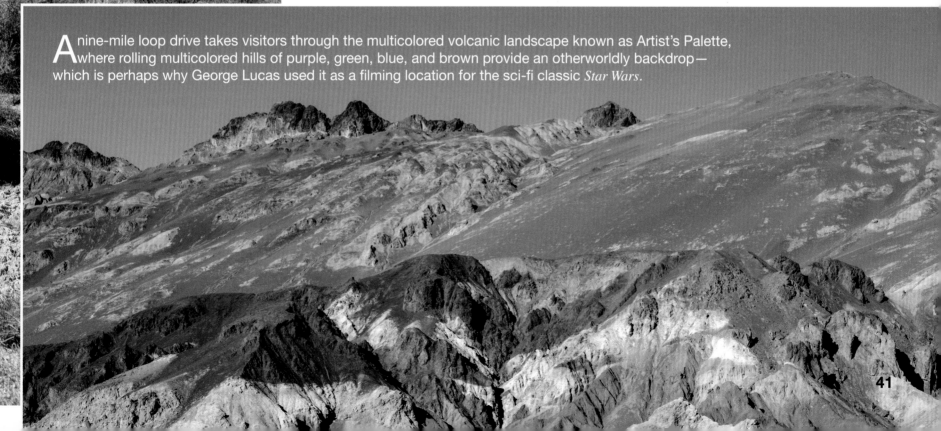

A nine-mile loop drive takes visitors through the multicolored volcanic landscape known as Artist's Palette, where rolling multicolored hills of purple, green, blue, and brown provide an otherworldly backdrop—which is perhaps why George Lucas used it as a filming location for the sci-fi classic *Star Wars*.

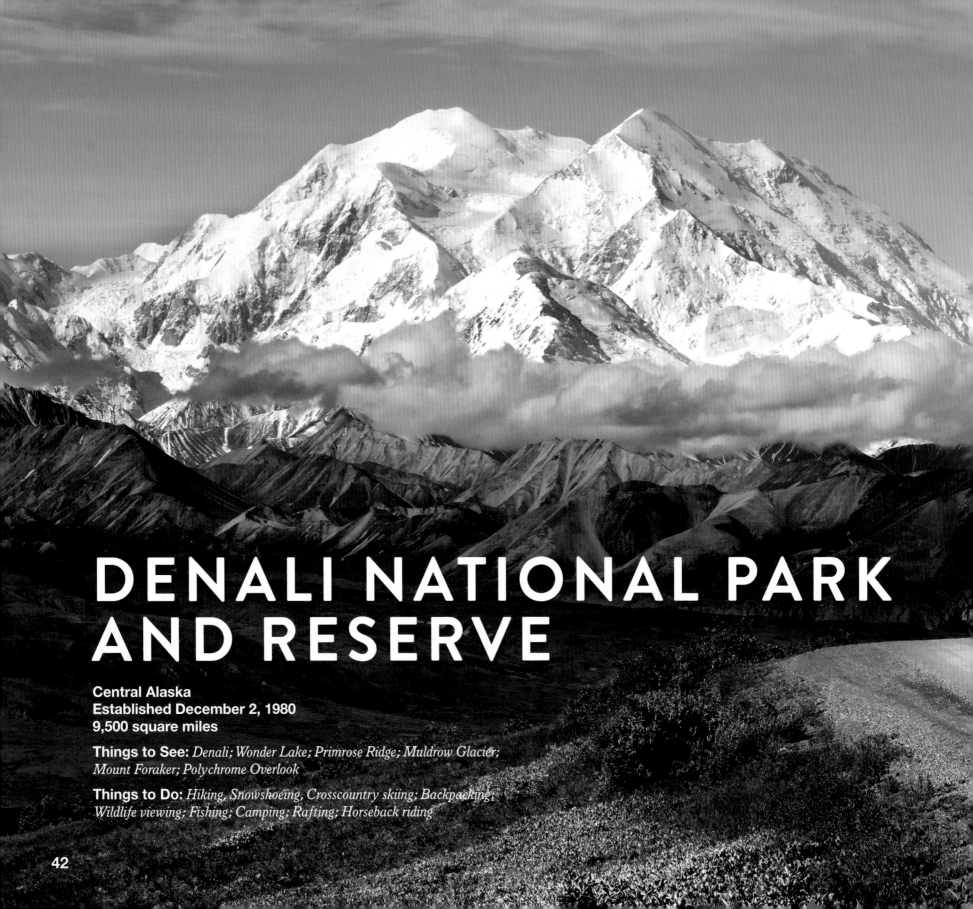

DENALI NATIONAL PARK AND RESERVE

Central Alaska
Established December 2, 1980
9,500 square miles

Things to See: *Denali; Wonder Lake; Primrose Ridge; Muldrow Glacier; Mount Foraker; Polychrome Overlook*

Things to Do: *Hiking, Snowshoeing, Crosscountry skiing; Backpacking; Wildlife viewing; Fishing; Camping; Rafting; Horseback riding*

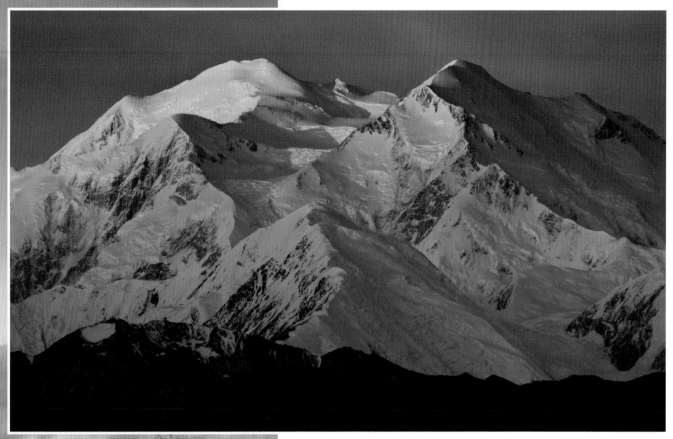

The park is dominated by the 20,320-foot mountain Denali, which the Athabaskan Indians simply call "Great One." Denali is the highest peak in North America.

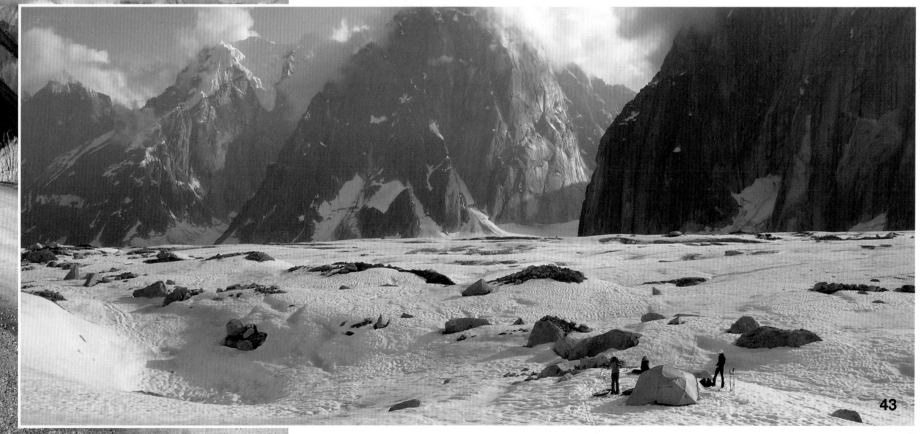

Denali National Park and Preserve was created to protect not the mountain but its dozens of species of mammals. *Ursus arctos horribilis*, the great grizzly, is the undisputed sovereign of this wild terrain.

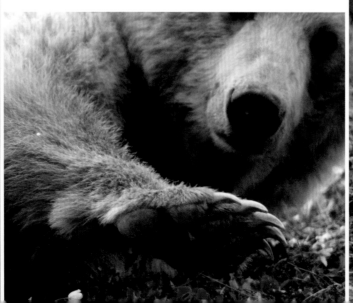

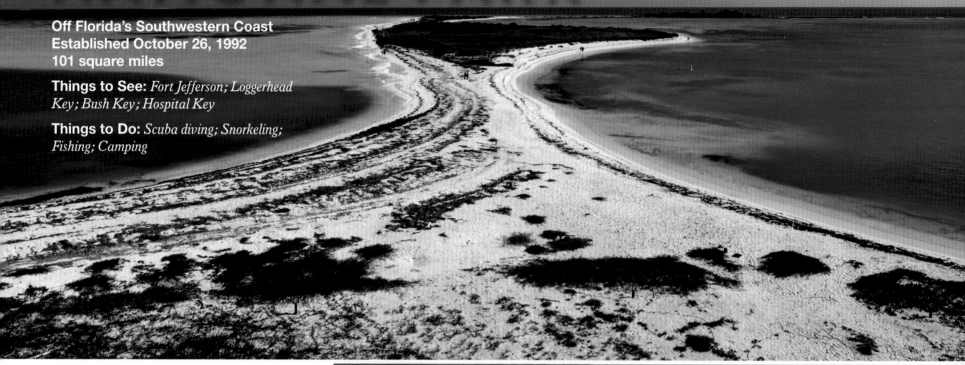

DRY TORTUGAS NATIONAL PARK

**Off Florida's Southwestern Coast
Established October 26, 1992
101 square miles**

Things to See: *Fort Jefferson; Loggerhead Key; Bush Key; Hospital Key*

Things to Do: *Scuba diving; Snorkeling; Fishing; Camping*

There's not much "dry" about the Dry Tortugas, an island group a little less than 70 miles west of Key West, Florida. The area derived the first part of its name from the fact that there are no sources of fresh water on the islands. The tortugas part of the name reaches back into history to Spanish explorer Ponce de Leon, who discovered the region in 1513. Despite the hardships of his voyage and the lack of potable water, the adventurer was pleased to be able to keep his ships stocked with sea turtles—in Spanish, *tortugas*.

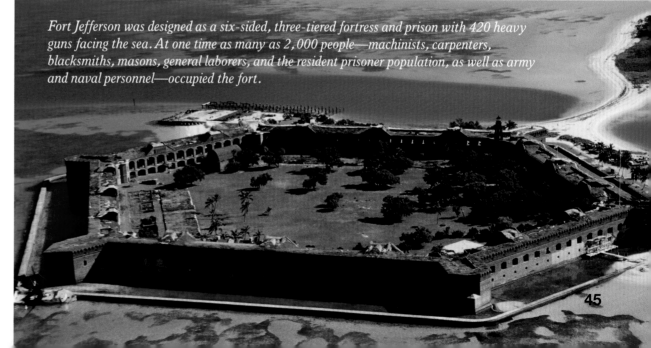

Fort Jefferson was designed as a six-sided, three-tiered fortress and prison with 420 heavy guns facing the sea. At one time as many as 2,000 people—machinists, carpenters, blacksmiths, masons, general laborers, and the resident prisoner population, as well as army and naval personnel—occupied the fort.

45

EVERGLADES NATIONAL PARK

Southern Florida
Established December 6, 1947
2,350 square miles

Things to See: *Shark Valley; Ten Thousand Islands; Flamingo; Wilderness Waterway*

Things to Do: *Boating; Kayaking; Fishing; Diving; Snorkeling; Airboat rides; Canoeing; Camping; Hiking; Bird-watching*

Everglades National Park is justly famed for its walkways, which are designed to take visitors through differing ecosystems. The result is a tour of a riotous variety of plant and animal life.

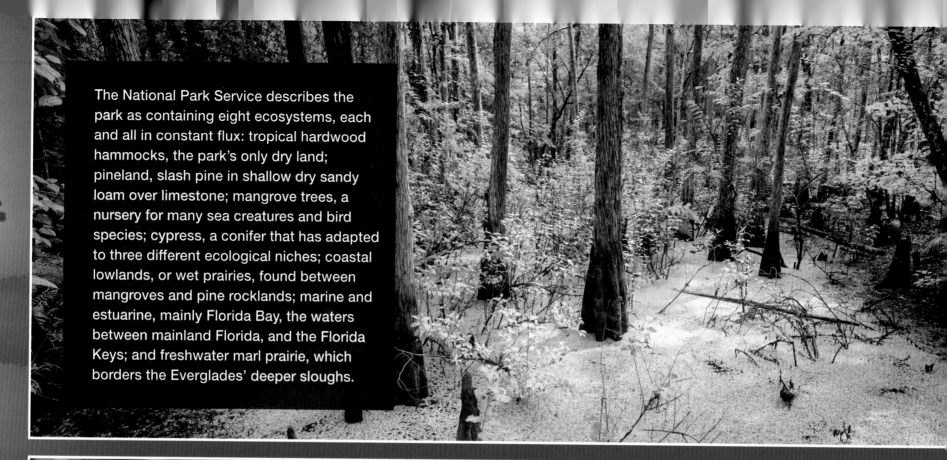

The National Park Service describes the park as containing eight ecosystems, each and all in constant flux: tropical hardwood hammocks, the park's only dry land; pineland, slash pine in shallow dry sandy loam over limestone; mangrove trees, a nursery for many sea creatures and bird species; cypress, a conifer that has adapted to three different ecological niches; coastal lowlands, or wet prairies, found between mangroves and pine rocklands; marine and estuarine, mainly Florida Bay, the waters between mainland Florida, and the Florida Keys; and freshwater marl prairie, which borders the Everglades' deeper sloughs.

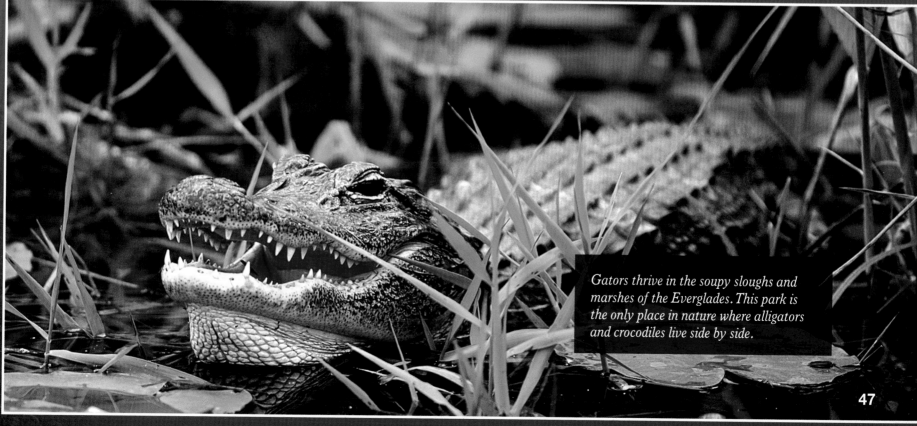

Gators thrive in the soupy sloughs and marshes of the Everglades. This park is the only place in nature where alligators and crocodiles live side by side.

47

GATES OF THE ARCTIC NATIONAL PARK AND RESERVE

Northern Alaska
Established December 2, 1980
13,238 square miles

Things to See: *Anaktuvuk Pass; Frigid Crags; Boreal Mountain; Mount Doonarak; Arrigetch Peaks; Mount Igikpak*

Things to Do: *Float plane trips; Camping; Hiking; Rock climbing; Bird-watching; Backpacking*

America's northernmost national park, Gates of the Arctic National Park and Preserve, has to be the most remote by any measure. It has no roads and no trails in from the outside. The entirety of Gates of the Arctic lies north of the Arctic Circle. The park is the centerpiece of 700 square miles of protected range, with the Noatak Preserve to the west and the Arctic National Wildlife Refuge to the east.

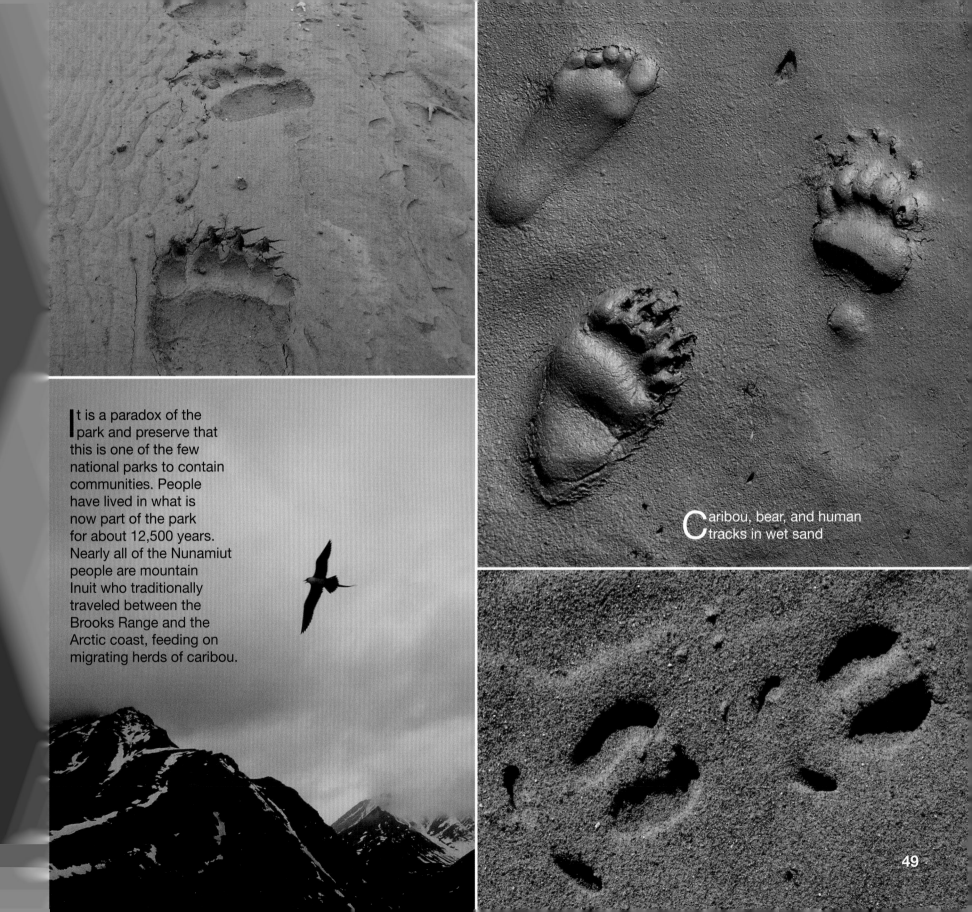

It is a paradox of the park and preserve that this is one of the few national parks to contain communities. People have lived in what is now part of the park for about 12,500 years. Nearly all of the Nunamiut people are mountain Inuit who traditionally traveled between the Brooks Range and the Arctic coast, feeding on migrating herds of caribou.

Caribou, bear, and human tracks in wet sand

49

GLACIER NATIONAL PARK

Northwestern Montana
Established May 11, 1910
1,583 square miles

Things to See: *Going-to-the-Sun Road; Logan Pass; Mount Logan; McDonald Lake; Sperry Glacier; Saint Mary Lake; West Glacier*

Things to Do: *Hiking; Backpacking; Camping; Horseback riding; Fishing; Cross-country skiing*

Northwestern Montana's Glacier National Park presents the Rocky Mountains as many have always imagined them: granite peaks with glimmering glaciers fitted into their gorges, fields run riot with wildflowers, lakes as deep and blue as the summer sky, cascading waterfalls, grizzly bears, wooded slopes, and miles and miles of wilderness trails.

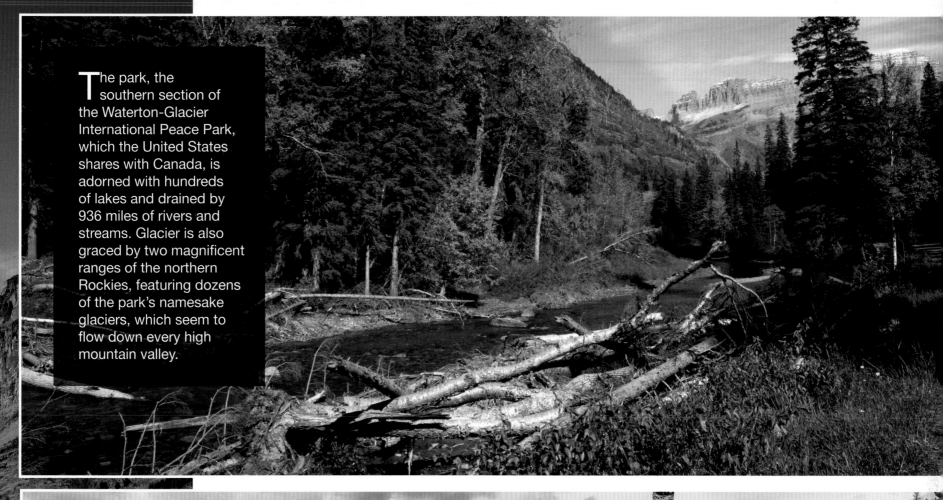

The park, the southern section of the Waterton-Glacier International Peace Park, which the United States shares with Canada, is adorned with hundreds of lakes and drained by 936 miles of rivers and streams. Glacier is also graced by two magnificent ranges of the northern Rockies, featuring dozens of the park's namesake glaciers, which seem to flow down every high mountain valley.

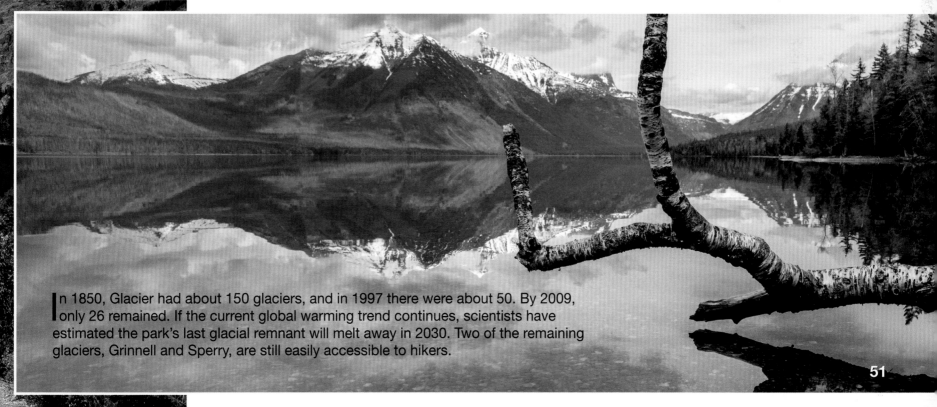

In 1850, Glacier had about 150 glaciers, and in 1997 there were about 50. By 2009, only 26 remained. If the current global warming trend continues, scientists have estimated the park's last glacial remnant will melt away in 2030. Two of the remaining glaciers, Grinnell and Sperry, are still easily accessible to hikers.

GLACIER BAY NATIONAL PARK AND RESERVE

Southeastern Alaska
Established December 2, 1980
5,130 square miles

Things to See: *Brady Glacier; Mount Fairweather; Grand Plateau Glacier; Bartlett Cove; Carroll Glacier; Marble Island*

Things to Do: *Hiking; Boating; Kayaking; Mountaineering; Rafting; Backpacking; Camping; Fishing*

The closest of Alaska's eight national parks to western Canada and the lower 48 states, the area around Glacier Bay in southeastern Alaska was first proclaimed a U.S. national monument in 1925. Glacier Bay National Park comprises 5,130 square miles; 4,164 square miles of it is designated as a wilderness area.

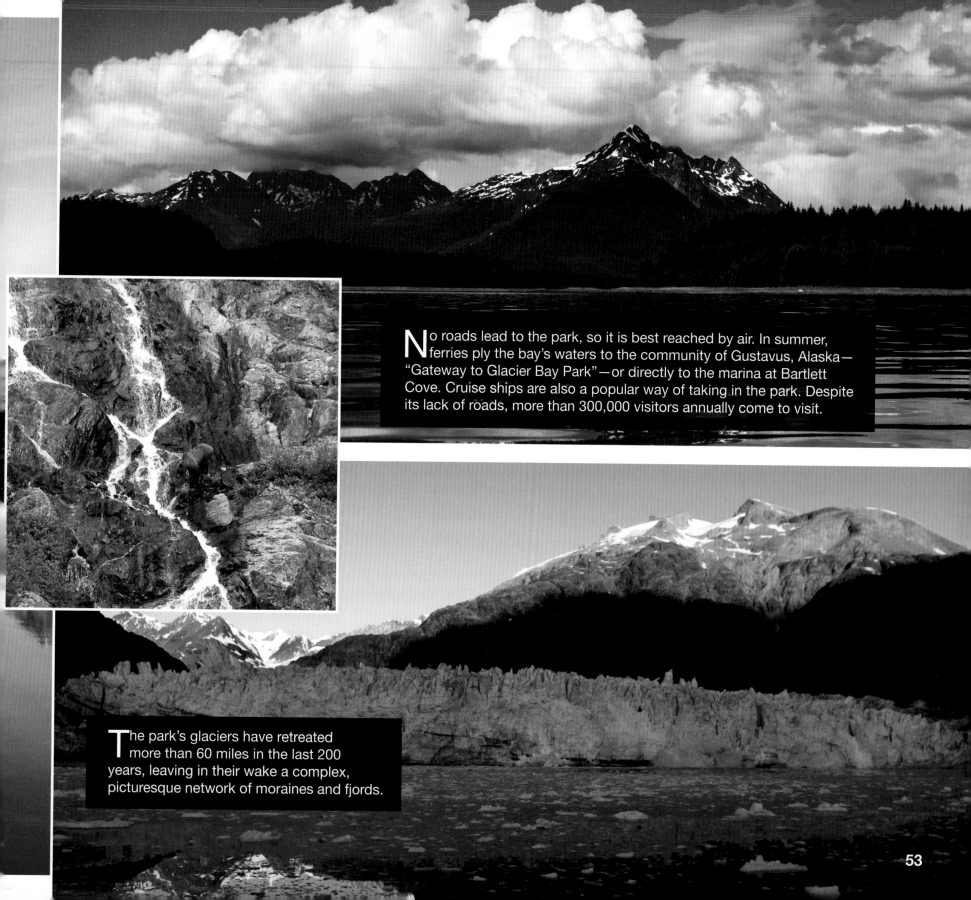

No roads lead to the park, so it is best reached by air. In summer, ferries ply the bay's waters to the community of Gustavus, Alaska—"Gateway to Glacier Bay Park"—or directly to the marina at Bartlett Cove. Cruise ships are also a popular way of taking in the park. Despite its lack of roads, more than 300,000 visitors annually come to visit.

The park's glaciers have retreated more than 60 miles in the last 200 years, leaving in their wake a complex, picturesque network of moraines and fjords.

GRAND CANYON NATIONAL PARK

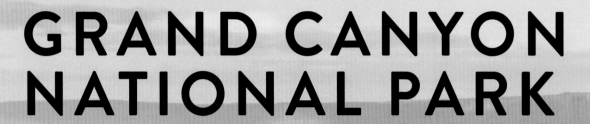

Northwestern Arizona
Established February 26, 1919
1,900 square miles

Things to See: *South Rim; North Rim; Bright Angel Trail; Phantom Ranch; Desert View; Desert View Watchtower; Tuweep; Toroweap Overlook; Tusayan Ruin and Museum; Point Imperial; Cape Royal*

Things to Do: *Hiking; Whitewater rafting; Mule trips; Camping; Backpacking*

Although there is no consensus on the Seven Natural Wonders of the World, the Grand Canyon is on virtually every short list—sometimes the only such landmark in the United States. More than four million visitors come to see the canyon every year, seeking its beauty beyond compare.

In 1857, Lieutenant Joseph Christmas Ives traveled up the Colorado from the Gulf of California for 350 miles by steamboat. "The region is, of course, altogether valueless," the hapless lieutenant wrote. "It seems intended by nature that the Colorado River, along with the greater portion of its lonely and majestic way, shall be forever unvisited and undisturbed."

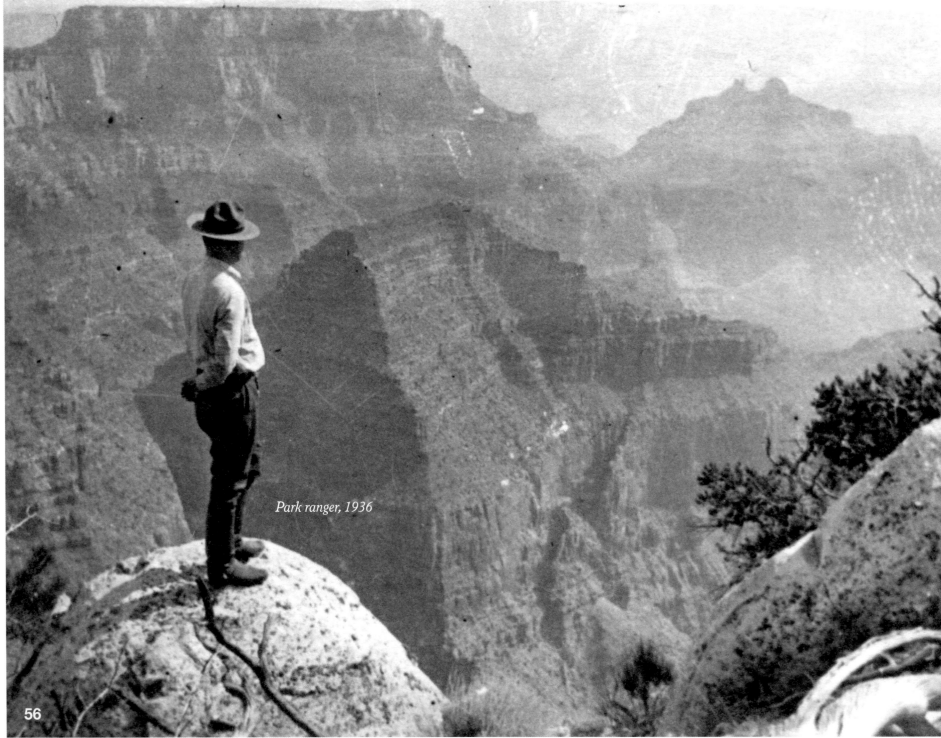

Park ranger, 1936

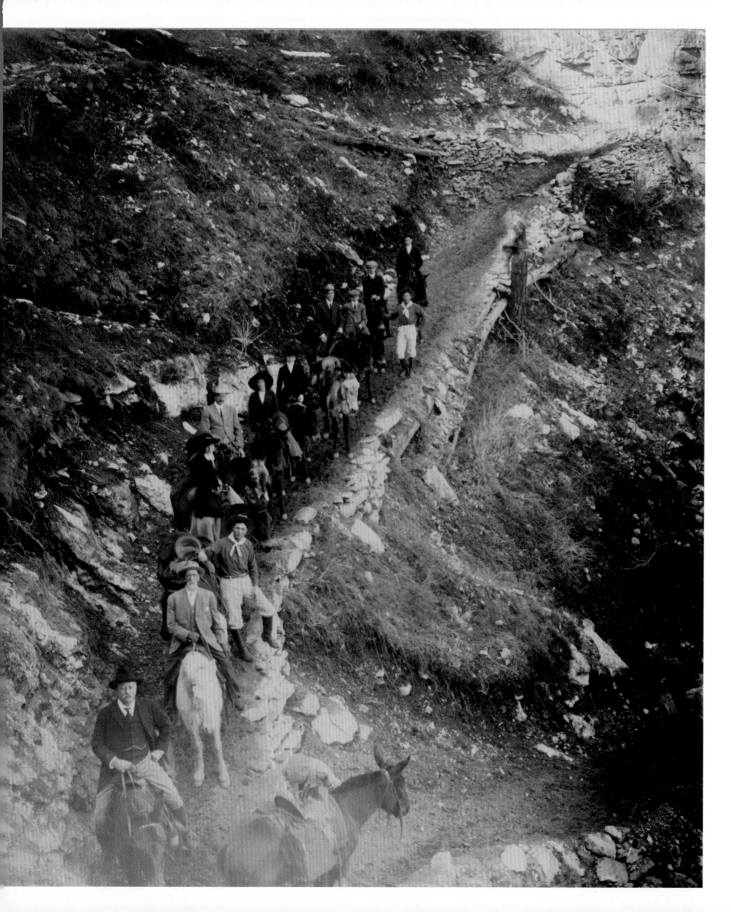

More than a century ago, the sight of the Grand Canyon stunned President Theodore Roosevelt into silence. When he recovered his voice, Roosevelt said, "In the Grand Canyon, Arizona has a natural wonder which, so far as I know, is in kind absolutely unparalleled throughout the rest of the world. . . . Leave it as it is. You cannot improve on it, and man can only mar it. What you can do is to keep it for your children, your children's children, and for all who come after you, as the one great sight which every American should see."

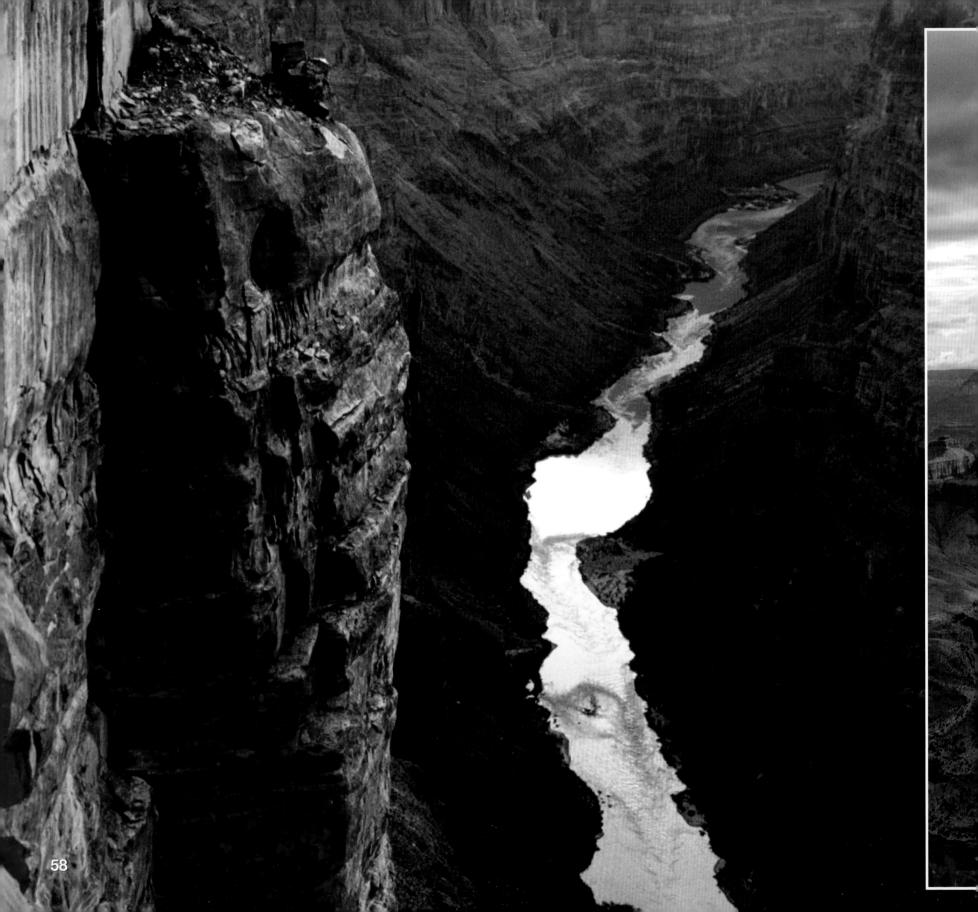

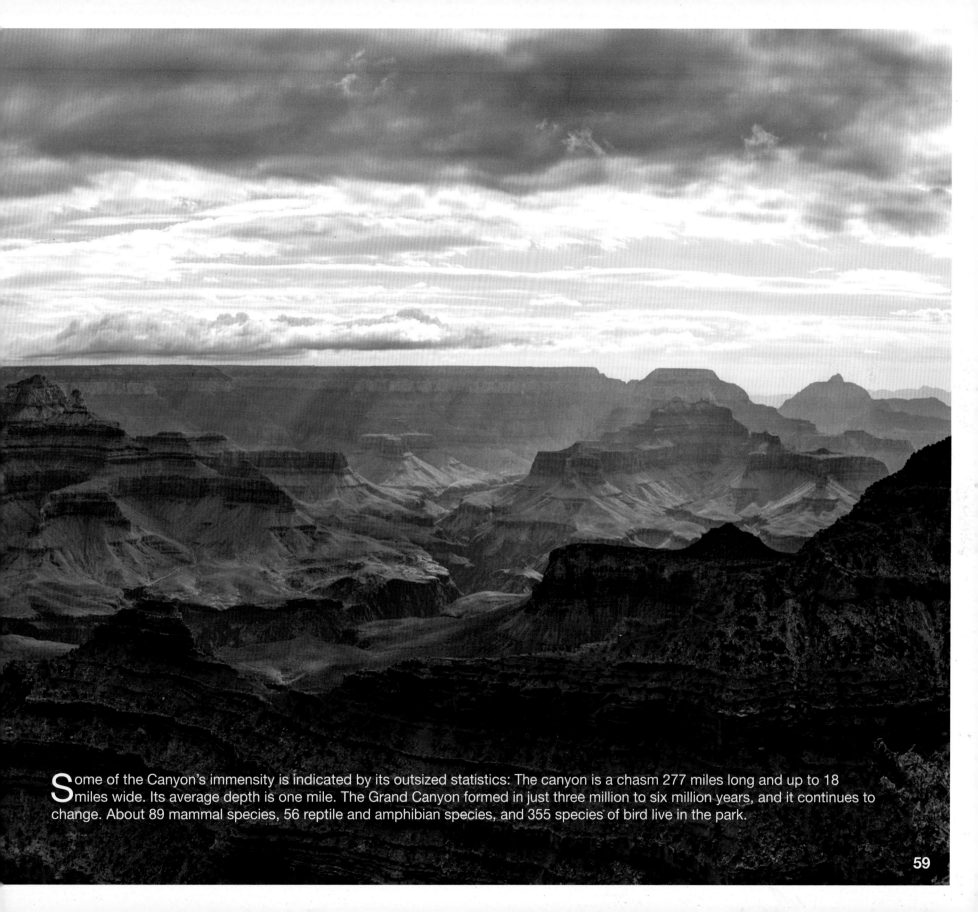

Some of the Canyon's immensity is indicated by its outsized statistics: The canyon is a chasm 277 miles long and up to 18 miles wide. Its average depth is one mile. The Grand Canyon formed in just three million to six million years, and it continues to change. About 89 mammal species, 56 reptile and amphibian species, and 355 species of bird live in the park.

GRAND TETON NATIONAL PARK

Northwest Wyoming
Established February 26, 1929
485 square miles

Things to See: *Grand Teton; Mount Owen; Jackson Lake; Mount Moran; Snake River; Menors Ferry Historic Area; Death Canyon; Signal Mountain, Cunningham Cabin Historic Site; Cascade Canyon; Jenny Lake*

Things to Do: *Hiking; Boating; Cross-country skiing; Backcountry camping; Rafting; Snow-shoeing; Biking; Bird-watching; Climbing; Fishing; Horseback riding*

The Tetons are some of the most beautiful mountains in the world. Their bold, soaring summits rise from the alpine valley known as Jackson Hole to peaks more than a mile above the Snake River's serpentine path on the floor. The Tetons, as a collective work of art, are one of nature's masterpieces.

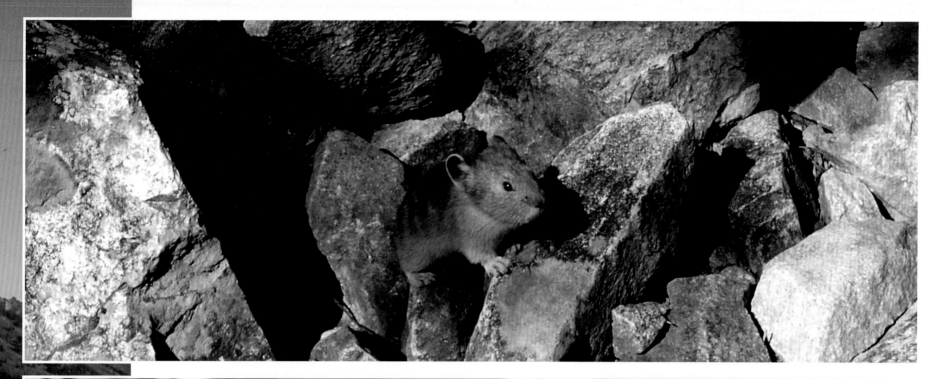

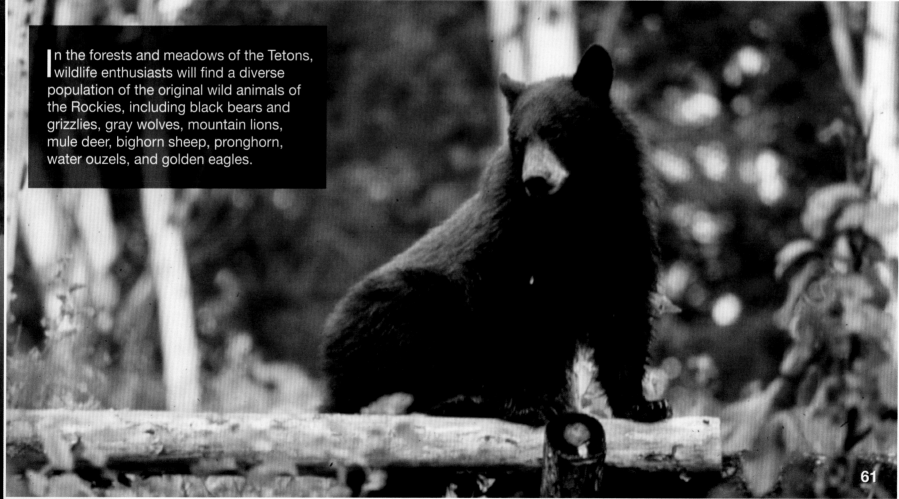

In the forests and meadows of the Tetons, wildlife enthusiasts will find a diverse population of the original wild animals of the Rockies, including black bears and grizzlies, gray wolves, mountain lions, mule deer, bighorn sheep, pronghorn, water ouzels, and golden eagles.

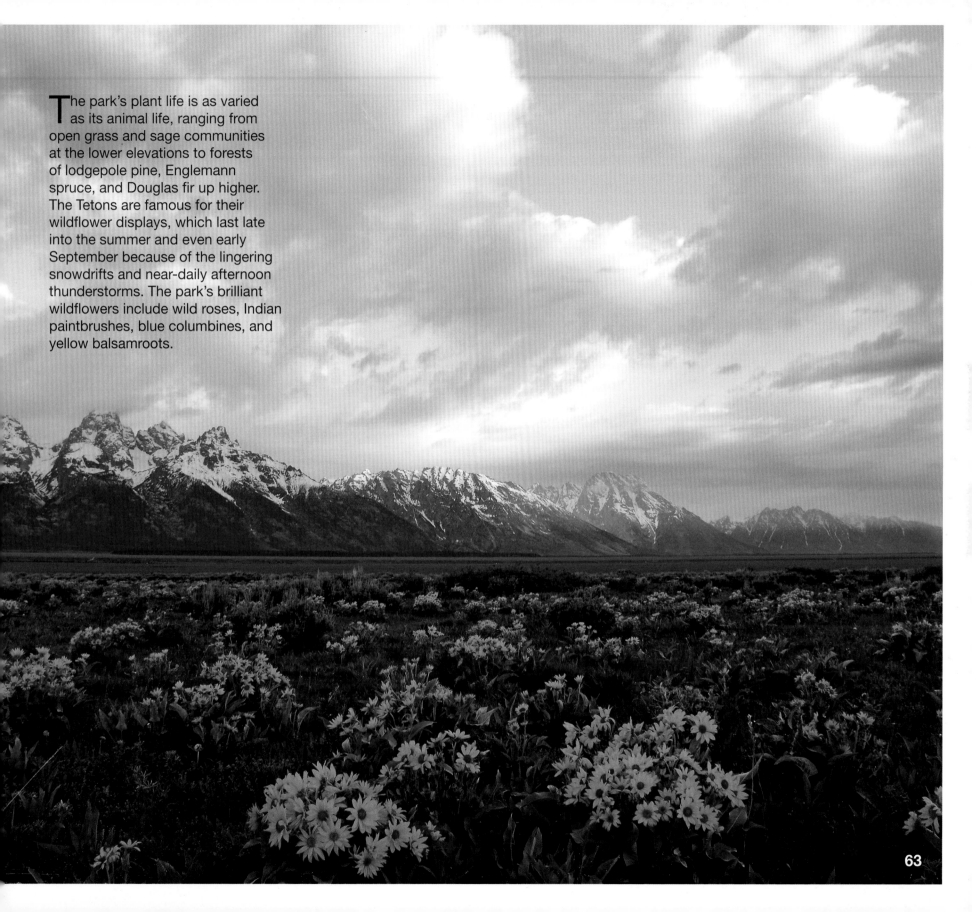

The park's plant life is as varied as its animal life, ranging from open grass and sage communities at the lower elevations to forests of lodgepole pine, Englemann spruce, and Douglas fir up higher. The Tetons are famous for their wildflower displays, which last late into the summer and even early September because of the lingering snowdrifts and near-daily afternoon thunderstorms. The park's brilliant wildflowers include wild roses, Indian paintbrushes, blue columbines, and yellow balsamroots.

WHO MET AT RENDEZVOUS PEAK?

The trappers of the late 18th century were some of the toughest in the world, not to mention the most educated in the ways of the land. Though very often illiterate, many could speak several languages, enabling them to translate and trade with local cultures and trappers from other countries. Many were skilled in combat—a necessity of the wilderness when trapping in territory that belonged to another. When more and more trappers were on the move, the Tetons became a thoroughfare.

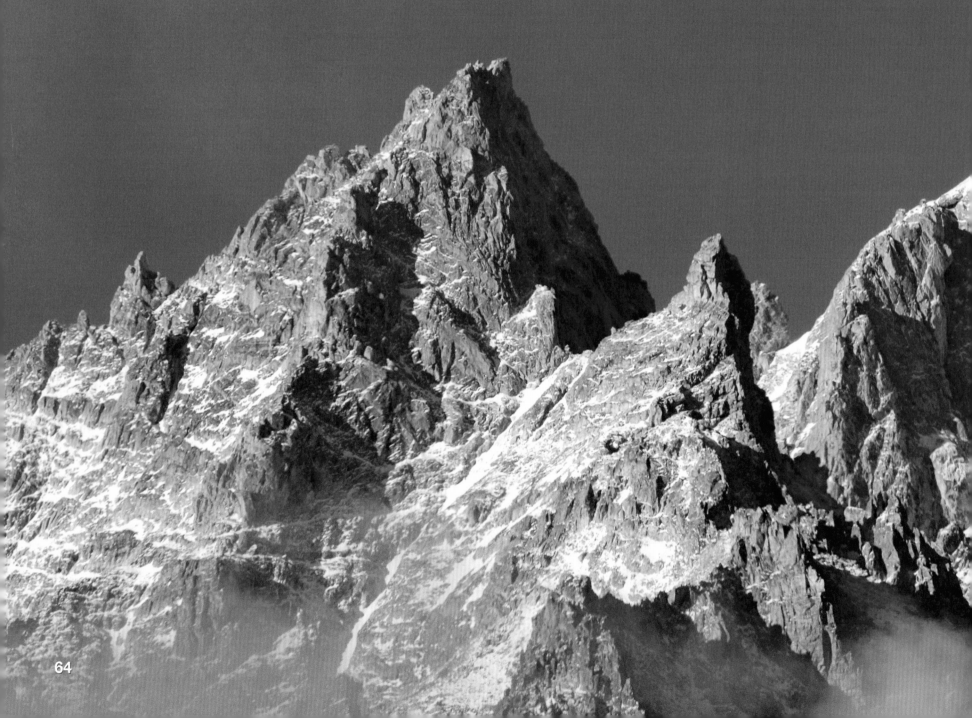

One group of trappers led by adventurer Jedediah Smith, a partner in Henry Ashley's fur company, thoroughly charted the Tetons area and came to know every spring and cranny. Not only was the landscape stunningly beautiful, it was teeming with beaver, bears, fish, eagles, and other wildlife to hunt and trap. The Grand Tetons became one of the trappers' favorite spots to meet. Every year trappers would leave signs for one another, telling the time and location so that all could come together for the "Rendezvous" in the spring. Traditionally, the meeting location moved with the trappers to a new place each year, but the Tetons were always popular. Visitors can still climb Rendezvous Peak in the southeastern corner of the park.

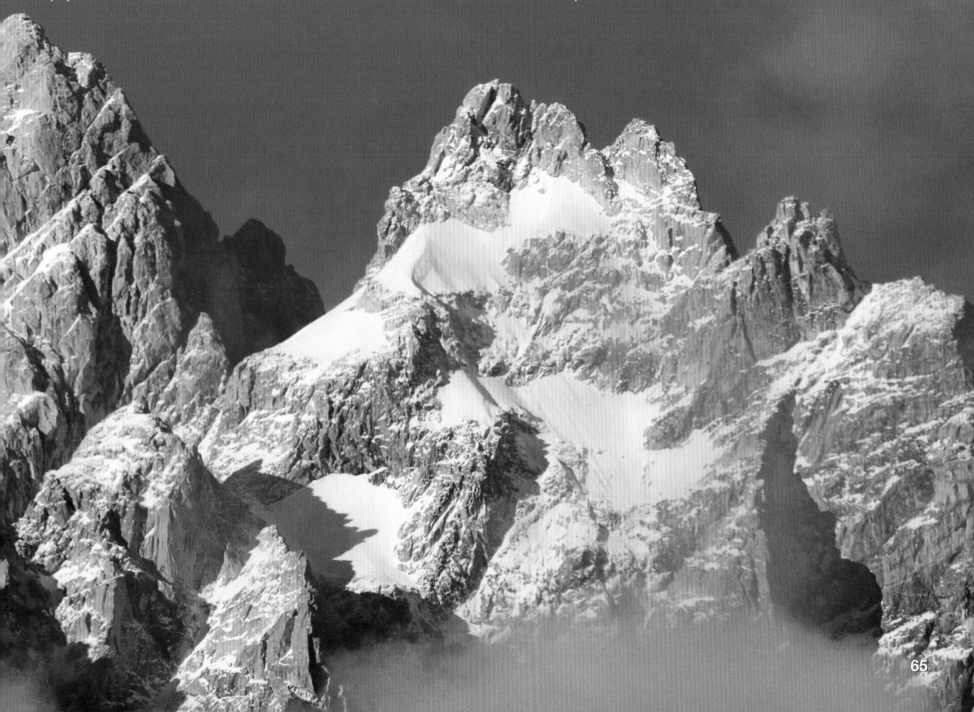

GREAT BASIN
NATIONAL PARK

Eastern Nevada
Established October 27, 1986
120 square miles

Things to See: *Wheeler Peak; Lehman Caves; Lexington Arch; Mather Overlook; Pole Canyon*

Things to Do: *Hiking; Backpacking; Bird-watching; Fishing; Caving; Horseback riding; Camping; Climbing*

Between the Rocky Mountains and the Sierra Nevada, in a remote corner of the vast, sparsely populated territory that stretches across the West, an unexpected and rugged landscape suddenly rises above the floor of the desert into the great blue of the eastern Nevada sky. Peaks carved by glaciers from a Pleistocene Ice Age tower more than a mile above the flat surface of the surrounding high desert.

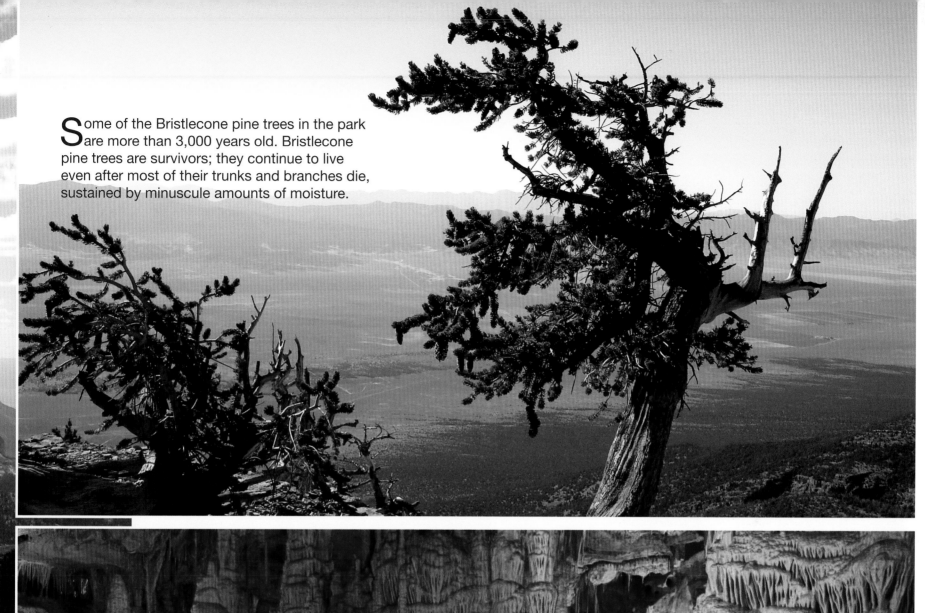

Some of the Bristlecone pine trees in the park are more than 3,000 years old. Bristlecone pine trees are survivors; they continue to live even after most of their trunks and branches die, sustained by minuscule amounts of moisture.

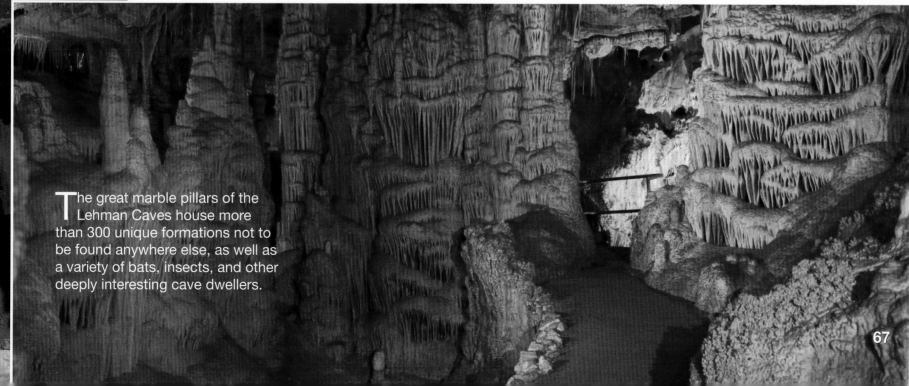

The great marble pillars of the Lehman Caves house more than 300 unique formations not to be found anywhere else, as well as a variety of bats, insects, and other deeply interesting cave dwellers.

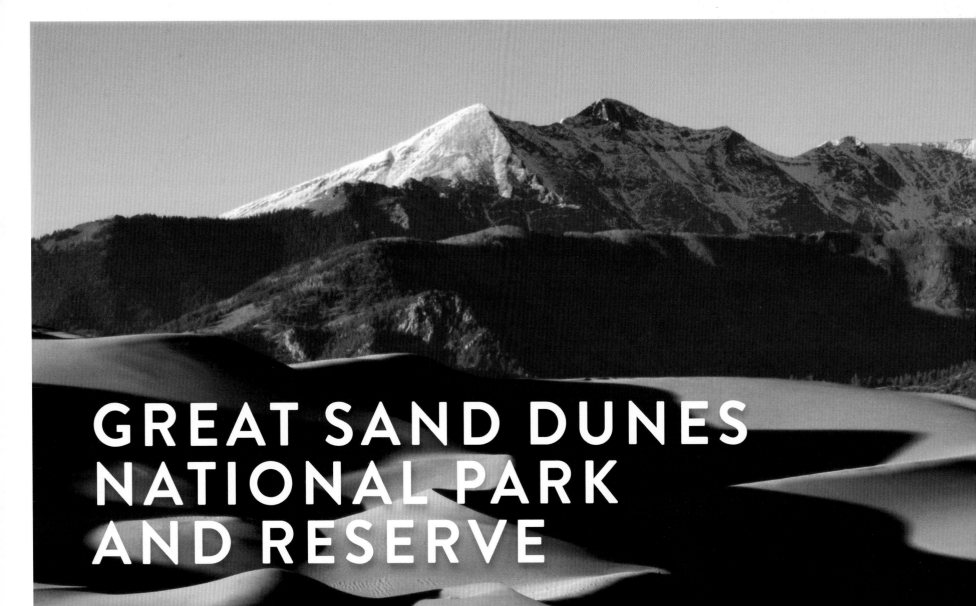

GREAT SAND DUNES NATIONAL PARK AND RESERVE

Southern Colorado
Established September 13, 2004
134 square miles

Things to See: *Star Dune; High Dune; Medano Creek; Medano Lake; Mount Herard; Sand Ramp Trail*

Things to Do: *Hiking; Backpacking; Sandboarding, skiing, and sledding; Horseback riding; Camping; Making sand castles*

Great Sand Dunes National Park and Preserve is home to the tallest dunes in North America, mountains of sand measuring 750 feet in height. The dunes were born about 440,000 years ago, the product of competing elements—wind and water—circulating and recirculating sand. Because there is no accurate way to date sand, however, the age of the dunes is an educated guess rather than a certainty.

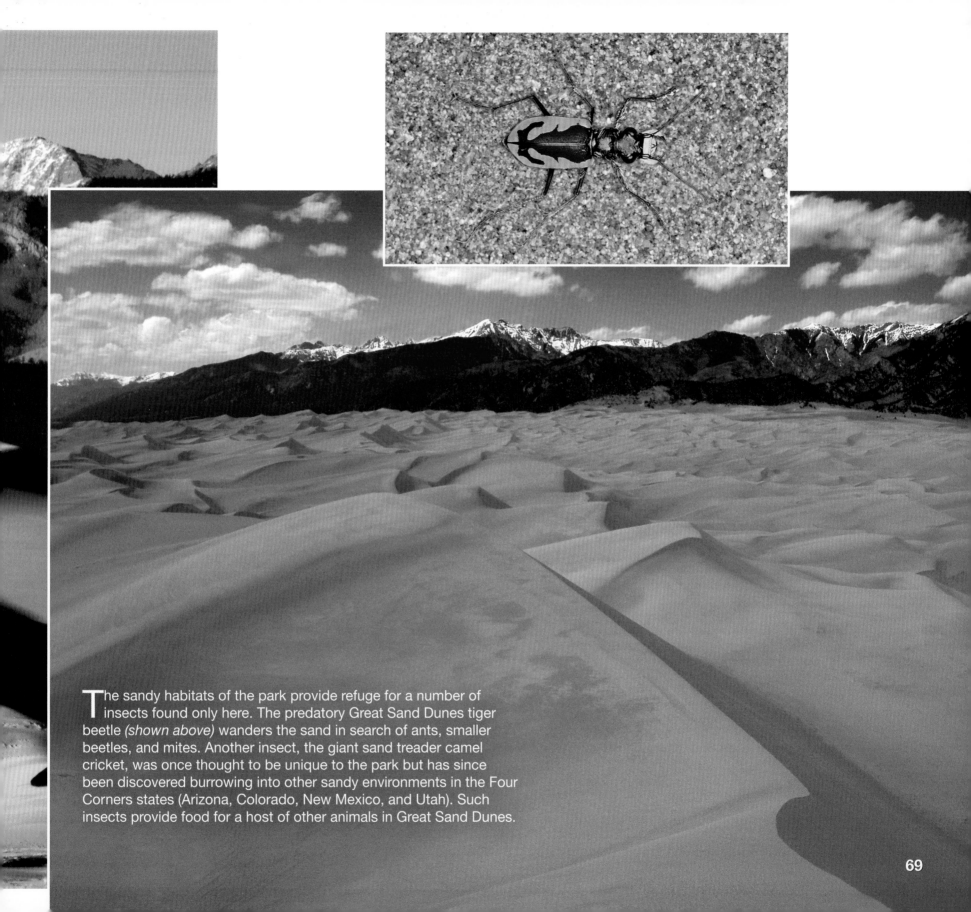

The sandy habitats of the park provide refuge for a number of insects found only here. The predatory Great Sand Dunes tiger beetle *(shown above)* wanders the sand in search of ants, smaller beetles, and mites. Another insect, the giant sand treader camel cricket, was once thought to be unique to the park but has since been discovered burrowing into other sandy environments in the Four Corners states (Arizona, Colorado, New Mexico, and Utah). Such insects provide food for a host of other animals in Great Sand Dunes.

GREAT SMOKY MOUNTAINS NATIONAL PARK

Eastern Tennessee and western North Carolina
Established June 15, 1934
810 square miles

Things to See: *Cades Cove; Clingmans Dome; Mount LeConte; Newfound Gap; Cataloochee; Fontana Dam; Mountain Farm Museum and Mingus Mill; Balsam Mountain; Chimney Tops*

Things to Do: *Hiking; Backpacking; Horseback riding; Fishing; Bicycling; Camping*

The Smokies harbor a unique blend of northern and southern animals and plants. Great Smoky Mountains National Park, the most visited national park, is a preserve of diversity, with more than 1,660 kinds of flowering plants, for instance, the largest number in any North American national park. More than 100 species of trees grow here, and the tangle of trees and brush

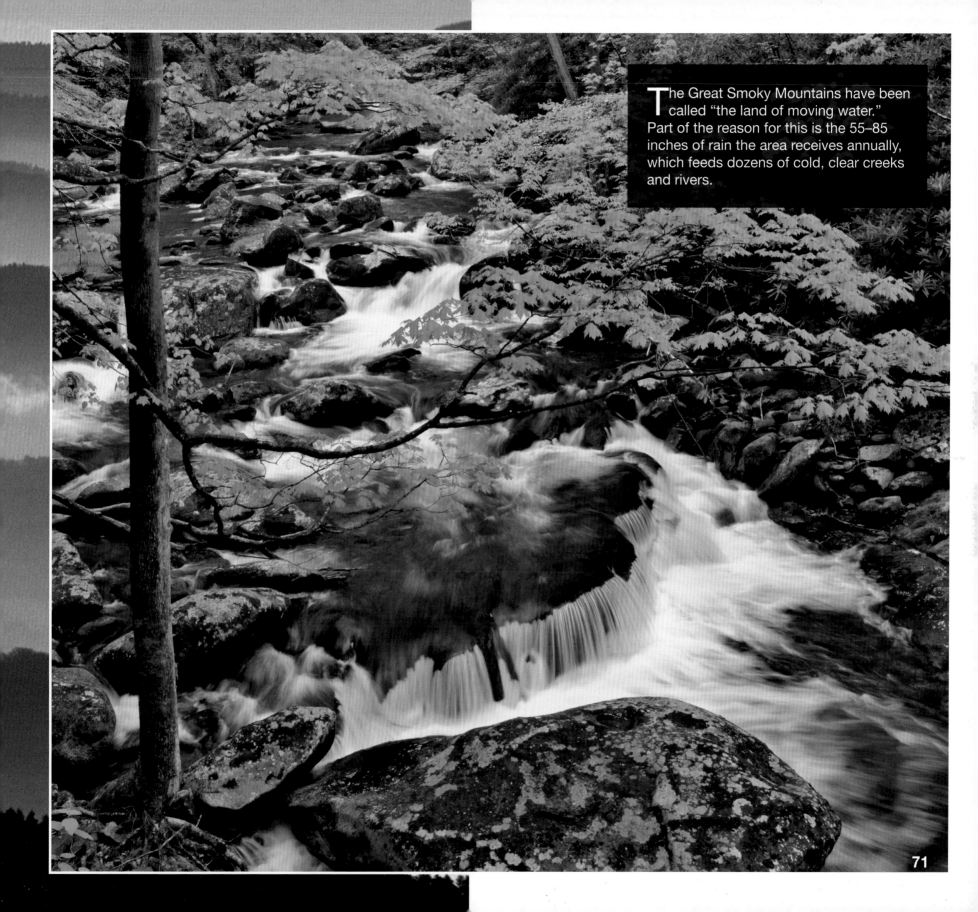

The Great Smoky Mountains have been called "the land of moving water." Part of the reason for this is the 55–85 inches of rain the area receives annually, which feeds dozens of cold, clear creeks and rivers.

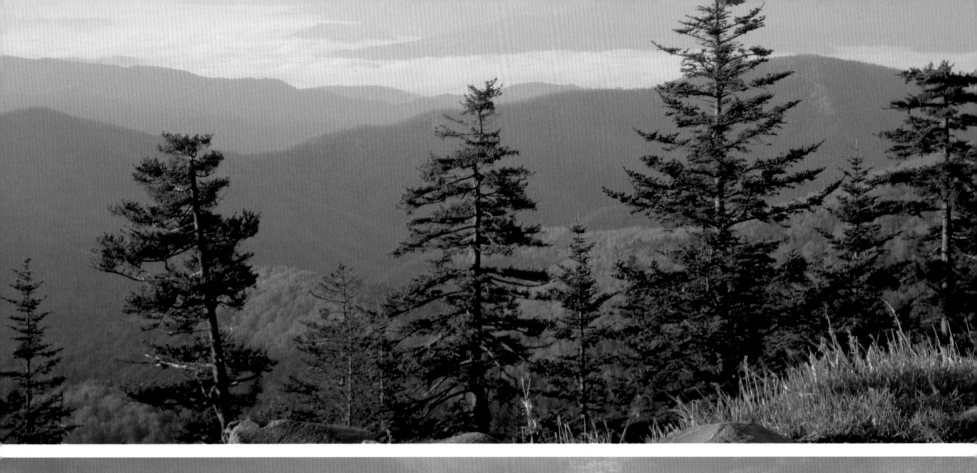

The park, which covers 810 square miles, or more than 521,000 acres along the high ridges of the mountains, has so many types of forest vegetation that it has been designated an International Biosphere Reserve. About half of this large, lush forest comprises virgin growth that dates back to well before colonial times; the park's cultural heritage is so significant it has also been recognized as a World Heritage Site.

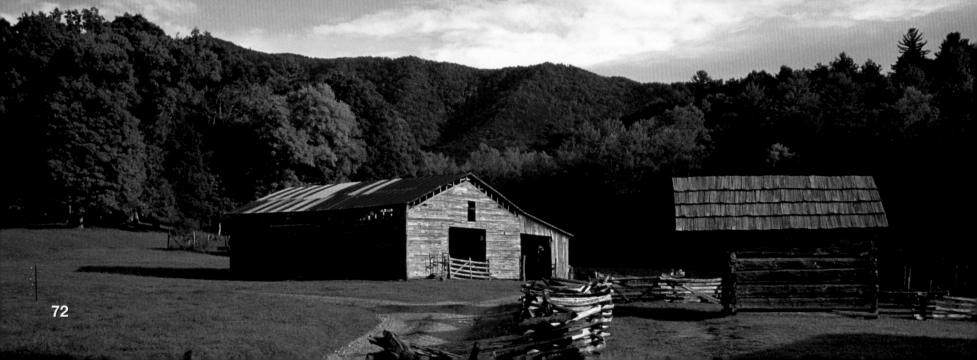

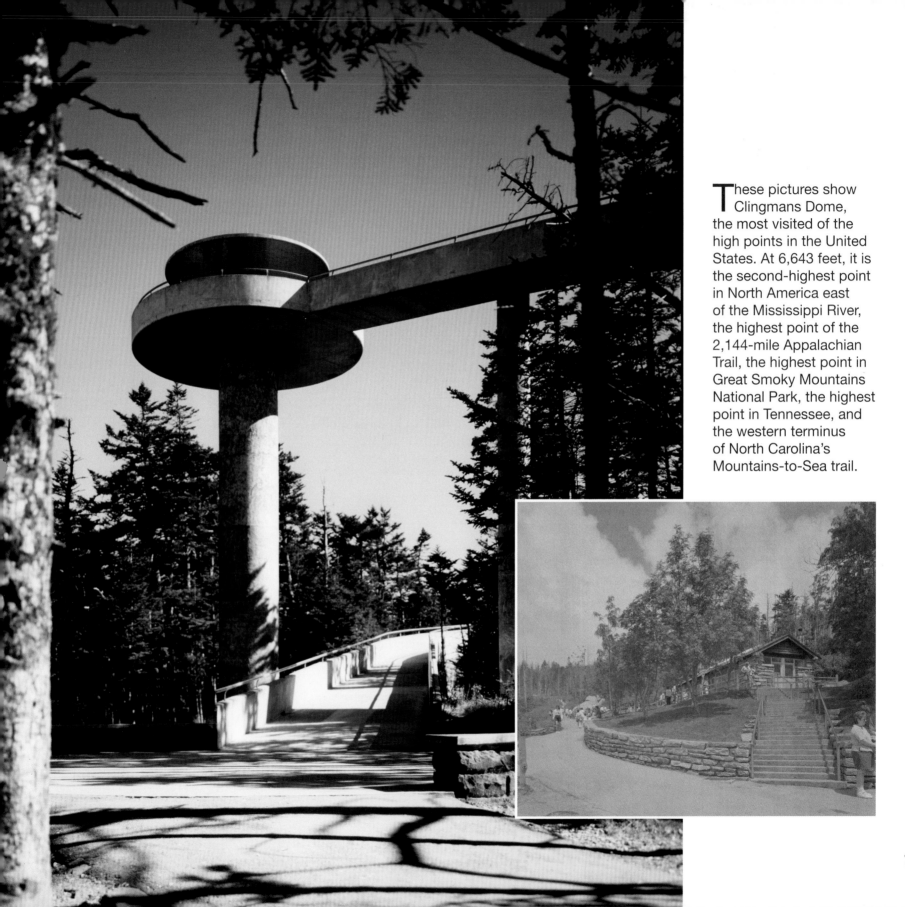

These pictures show Clingmans Dome, the most visited of the high points in the United States. At 6,643 feet, it is the second-highest point in North America east of the Mississippi River, the highest point of the 2,144-mile Appalachian Trail, the highest point in Great Smoky Mountains National Park, the highest point in Tennessee, and the western terminus of North Carolina's Mountains-to-Sea trail.

GUADALUPE MOUNTAINS NATIONAL PARK

Western Texas
Established October 15, 1966
135 square miles

Things to See: *El Capitan; Guadalupe Peak; Bush Mountain; Shumard Peak; Bartlett Peak; Dog Canyon; McKittrick Canyon; Frijole Ranch History Museum; Salt Basin Dunes; Williams Ranch*

Things to Do: *Hiking, Camping, Backpacking, Horseback riding; Bird-watching*

The dry flatlands of the Chihuahan Desert, a vast, mostly barren stretch of cactus and greasewood that extends for hundreds of miles across West Texas and south into Mexico, seem an unlikely place to find an ocean reef. But here, hundreds of miles from the nearest saltwater, an immense escarpment of orange and red limestone that was once at the bottom of a sea glistens in the bright sunlight: Guadalupe Mountains National Park in far northwest Texas.

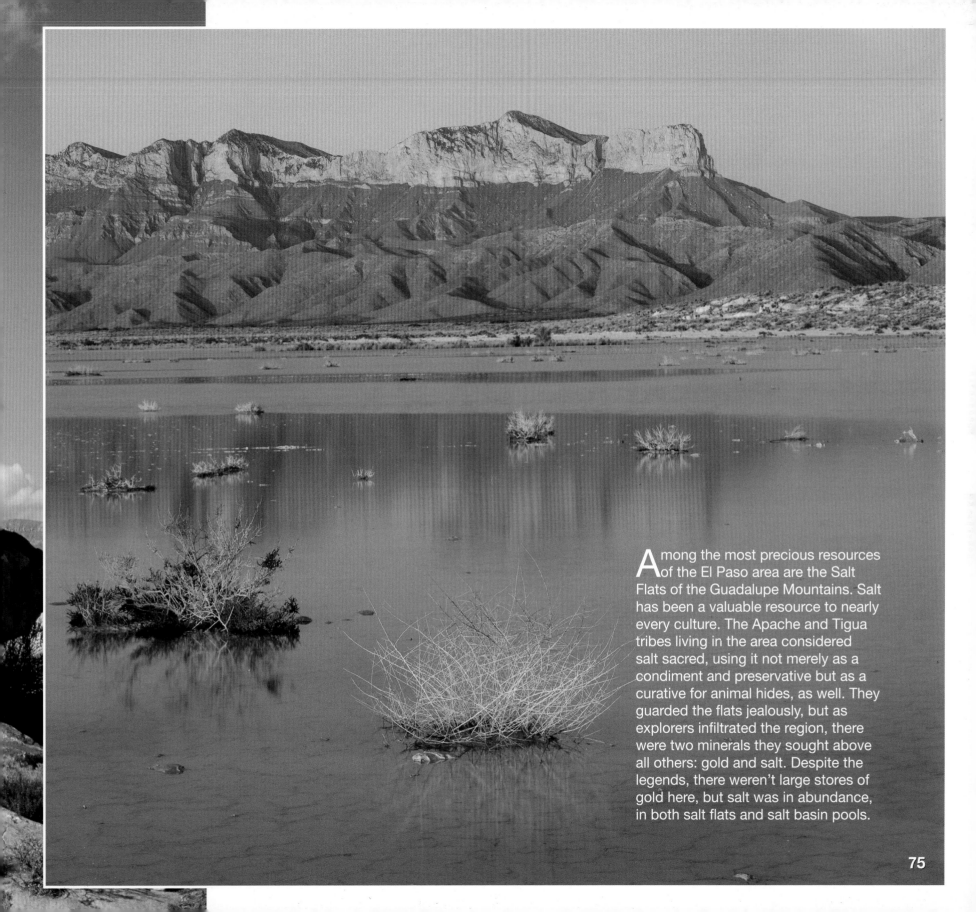

Among the most precious resources of the El Paso area are the Salt Flats of the Guadalupe Mountains. Salt has been a valuable resource to nearly every culture. The Apache and Tigua tribes living in the area considered salt sacred, using it not merely as a condiment and preservative but as a curative for animal hides, as well. They guarded the flats jealously, but as explorers infiltrated the region, there were two minerals they sought above all others: gold and salt. Despite the legends, there weren't large stores of gold here, but salt was in abundance, in both salt flats and salt basin pools.

HALEAKALA NATIONAL PARK

Hawaiian island of Maui
Established July 1, 1961
45 square miles

Things to See: *Haleakala summit area; Kipahulu valley; Haleakala Wilderness*

Things to Do: *Hiking; Backpacking; Stargazing; Camping; Bird-watching*

A mighty volcano named Haleakala sleeps within the domain of Haleakala National Park on the Hawaiian island of Maui. This huge, dormant volcano—a wild moonscape that extends for 33 miles in one direction and 24 miles in the other—is capped by a circular crater of 19 square miles. The volcano's floor, 2,720 feet below the summit, is a starkly beautiful and forbidding landscape of cinder cones and sculptured lava colored with startling shades of red and yellow. Haleakala is a volcano that has grown cold, at least for now, but its enormous crater is filled with unearthly shapes and profiles that are vivid reminders of its fiery past.

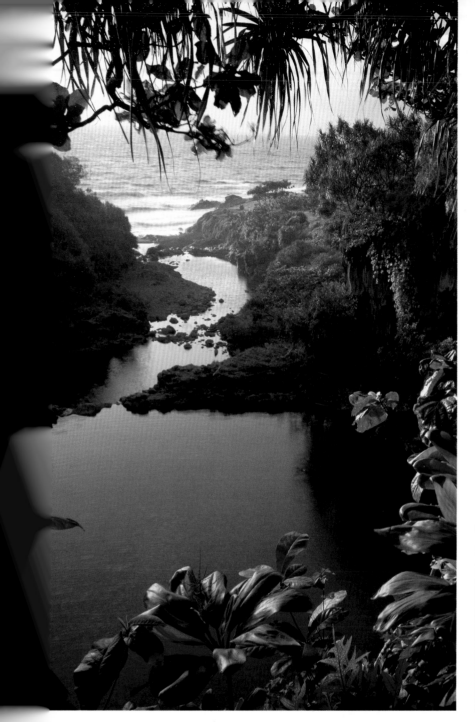
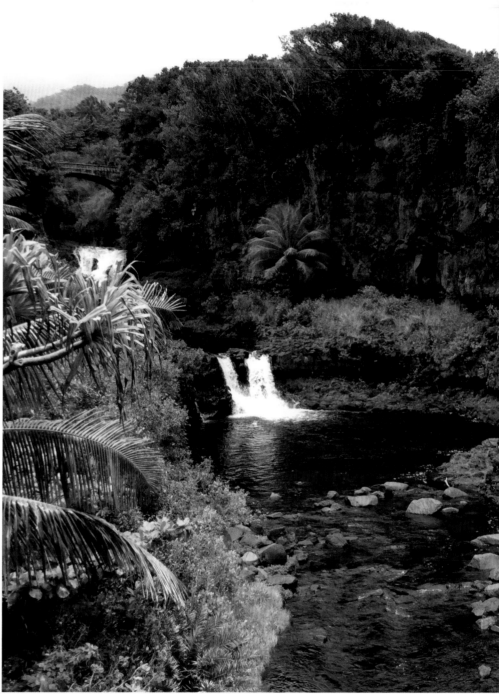

Haleakala represents one portion of its self-named park. The other is Kipahulu. This section of the park features more than two dozen pools of rare native freshwater fish. Visitors may swim in the pools or hike a trail that takes them up to the base of Waimoku Falls. The contrast between the Haleakala and Kipahulu sections of the park could not be greater. Haleakala is dominated by volcanic vents and towering cinders. Kipahulu Valley—where rain forests receive as much as 250 inches of annual rainfall—is all lush pools, cascading waterfalls, and plunging, swirling streams.

HAWAI'I VOLCANOES NATIONAL PARK

Hawaiian island of Hawai'i
Established September 22, 1961
505 square miles

Things to See: *Kilauea; Crater Rim Drive; Chain of Craters Road; Jaggar Museum; Thurston Lava Tube*

Things to Do: *Hiking; Lava viewing; Camping; Biking*

Roughly 1.6 million visitors arrive annually to see Hawai'i Volcanoes National Park, which is 30 miles from Hilo, Hawaii. The area was made a national park in 1916, and it included the Mauna Loa and Kilauea volcanoes along with what today is Haleakala National Park on the island of Maui.

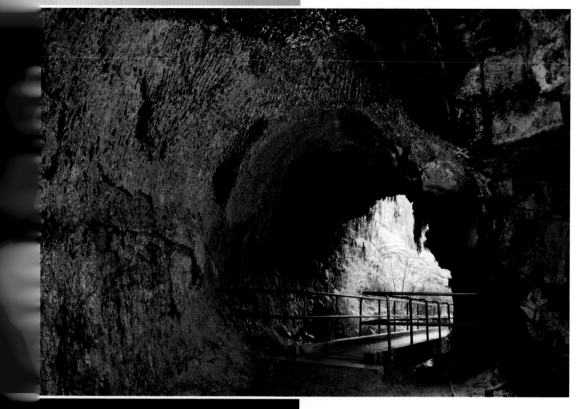

For centuries, Hawaiian legends have explained the way volcanic islands form. It was all the doing of Pele, the goddess of fire. Pele was (or is) a cranky goddess who from time to time would lose patience with her brothers and sisters.

When Pele became angry, her very voice became *pu,* or explosive. *Pu* is the word in the Hawaiian language that was later given to "gun," but it was originally reserved to describe the explosions of gas in volcanic eruptions. Pele liked to move around the islands, and when she stamped her foot, she could make the earth tremble and form new islands.

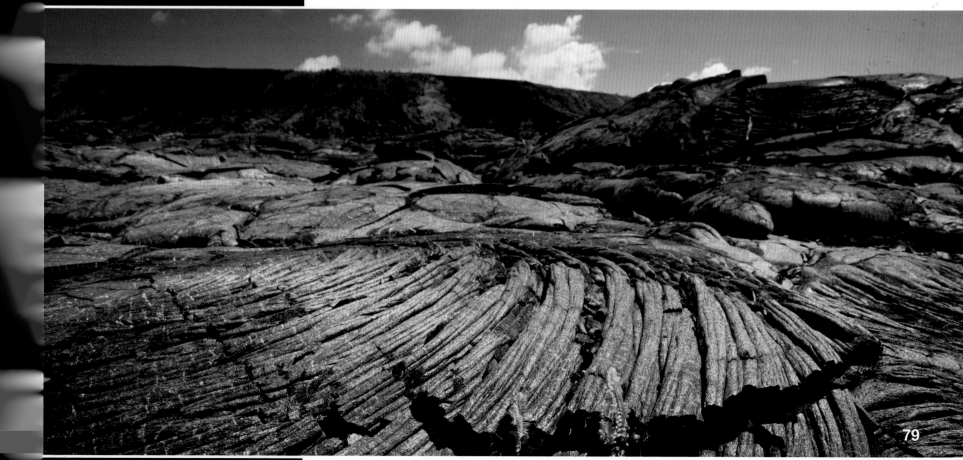

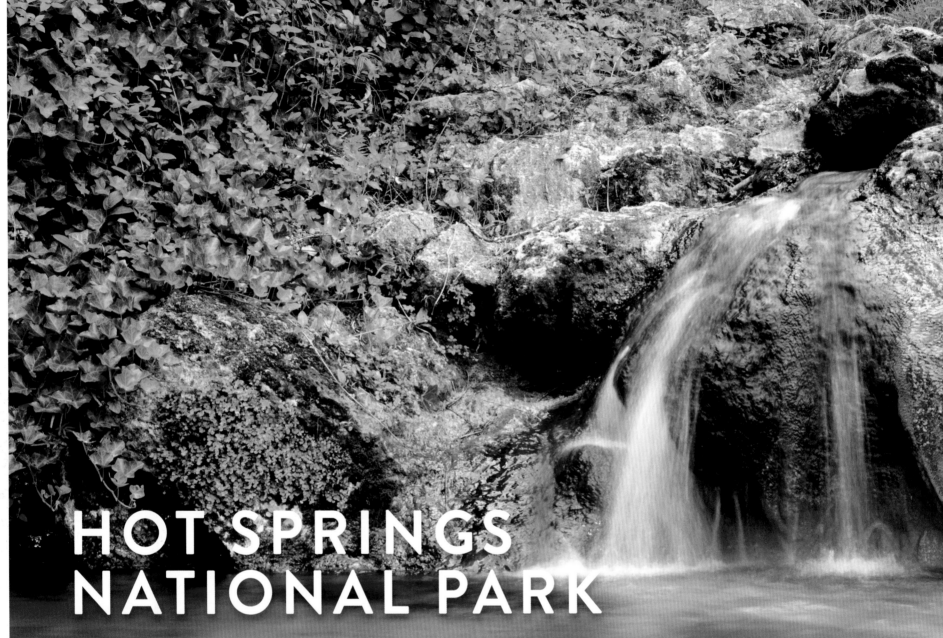

HOT SPRINGS NATIONAL PARK

Southern Arkansas
Established March 4, 1921
9 square miles

Things to See: *Bathhouse Row; Fordyce Bathhouse; Hot Springs Mountain Tower; Sugarloaf Mountain; Music Mountain; North Mountain; West Mountain*

Things to Do: *Hiking; Horseback riding; Bird-watching; Soaking and bathing*

In many ways Hot Springs National Park is the most unusual national park in the federal system. It has stood out from the rest almost since the area was first acquired by the United States as a part of the Louisiana Purchase in 1803. Hot Springs National Park has existed in some sort of park form since 1832, when Andrew Jackson was president. It is the smallest national park, the only one surrounded by a city, and surely the only national park in which the focus of interest is its bathhouses.

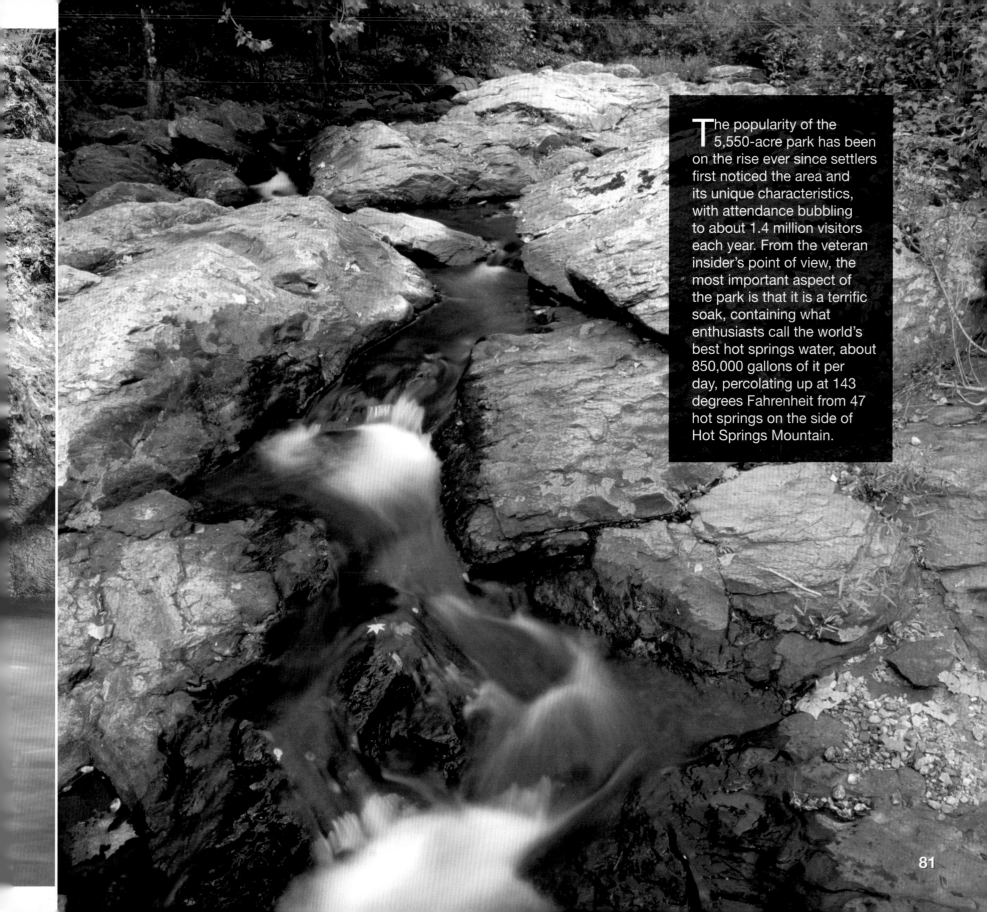

The popularity of the 5,550-acre park has been on the rise ever since settlers first noticed the area and its unique characteristics, with attendance bubbling to about 1.4 million visitors each year. From the veteran insider's point of view, the most important aspect of the park is that it is a terrific soak, containing what enthusiasts call the world's best hot springs water, about 850,000 gallons of it per day, percolating up at 143 degrees Fahrenheit from 47 hot springs on the side of Hot Springs Mountain.

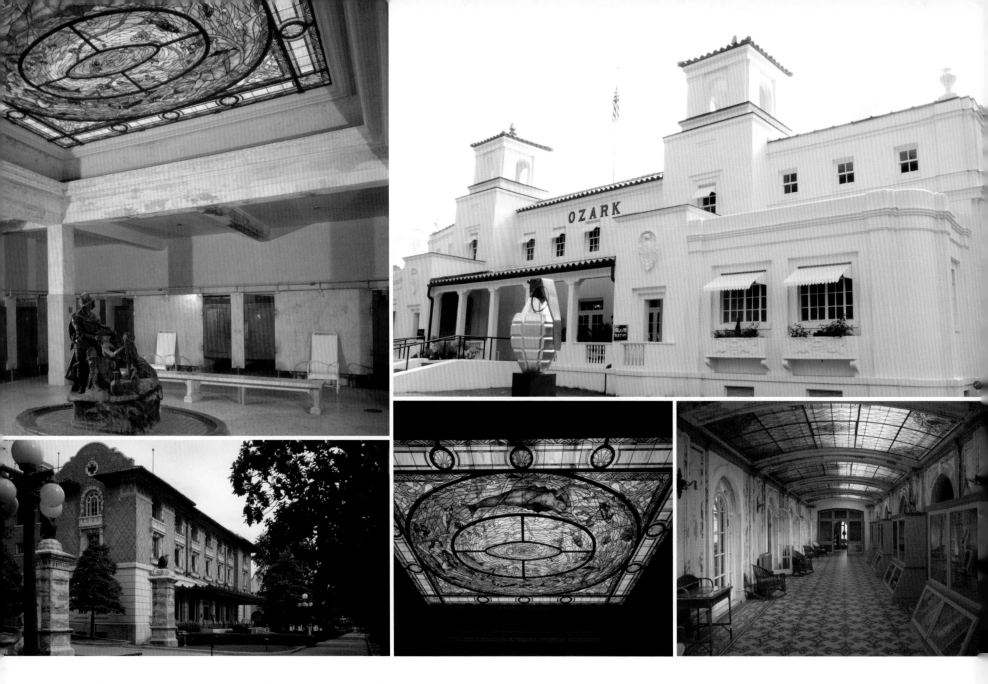

In 1916, Congress established the National Park Service. In 1921, Hot Springs Reservation became Hot Springs National Park. By the 1950s, however, a long decline had begun. The Fordyce Bathhouse closed in 1962, and more closings followed in the 1970s. Bathhouse Row and its environs were placed on the National Register of Historic Places on November 13, 1974, but that did not stanch the drain on business. In 1984, further bathhouses closed, and when the Lamar Bathhouse shut its doors the next year, the Buckstaff stood as the last survivor of Bathhouse Row. But just a few years later in 1989, the deluxe Fordyce Bathhouse reopened. It had been adapted for use as the park museum and visitor center, its original furnishings restored or replaced with replicas. In the Fordyce Bathhouse today, tourists can see stained-glass windows, assorted statuary, and gleaming pipes, as well as luxurious tubs like the ones in which the aficionados of another age undertook three-week therapy courses of daily hot baths and massages.

ISLE ROYALE NATIONAL PARK

Northern Michigan
Established April 3, 1940
893 square miles

Things to See: *Rock Harbor; Siskiwit Bay; Windigo Area*

Things to Do: *Kayaking and canoeing; Hiking; Camping; Scuba diving; Berry picking*

Isle Royale, the largest island in the world's largest freshwater lake, has no roads, but it has 165 miles of hiking trails. It can be reached only by boat, seaplane, or ferry. Together with hundreds of small islands, it makes up Isle Royale National Park in the waters of Lake Superior, north of Michigan's Upper Peninsula.

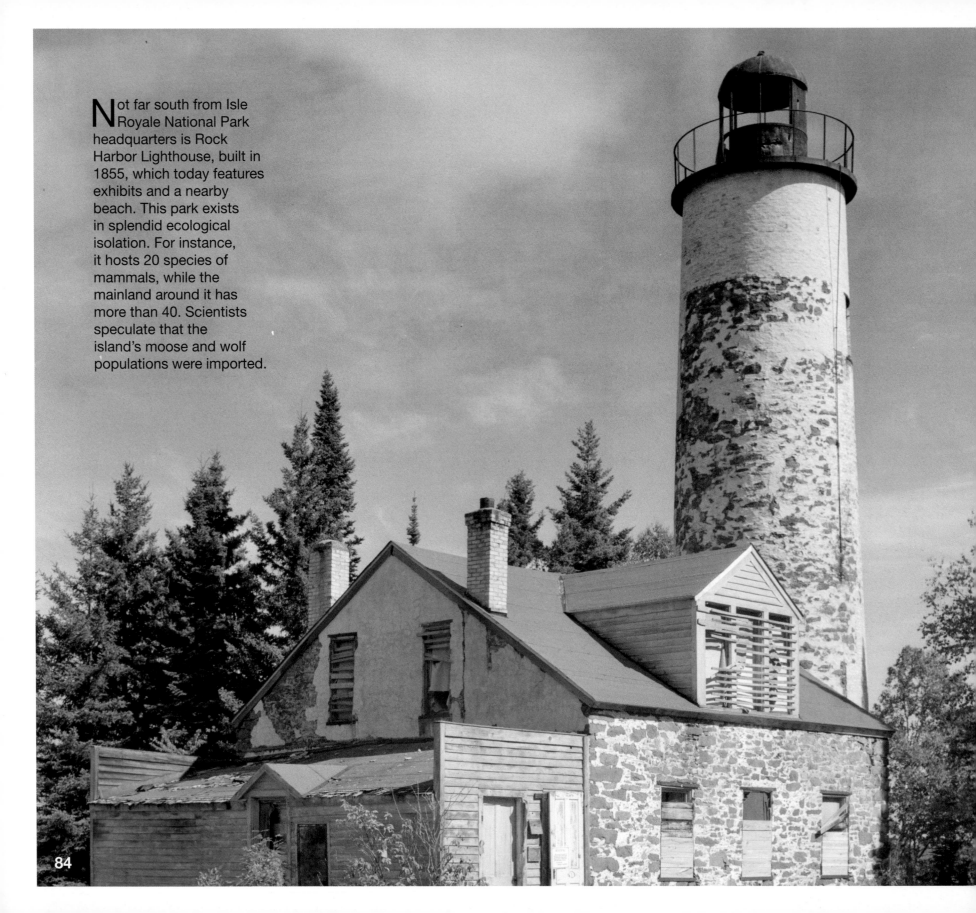

Not far south from Isle Royale National Park headquarters is Rock Harbor Lighthouse, built in 1855, which today features exhibits and a nearby beach. This park exists in splendid ecological isolation. For instance, it hosts 20 species of mammals, while the mainland around it has more than 40. Scientists speculate that the island's moose and wolf populations were imported.

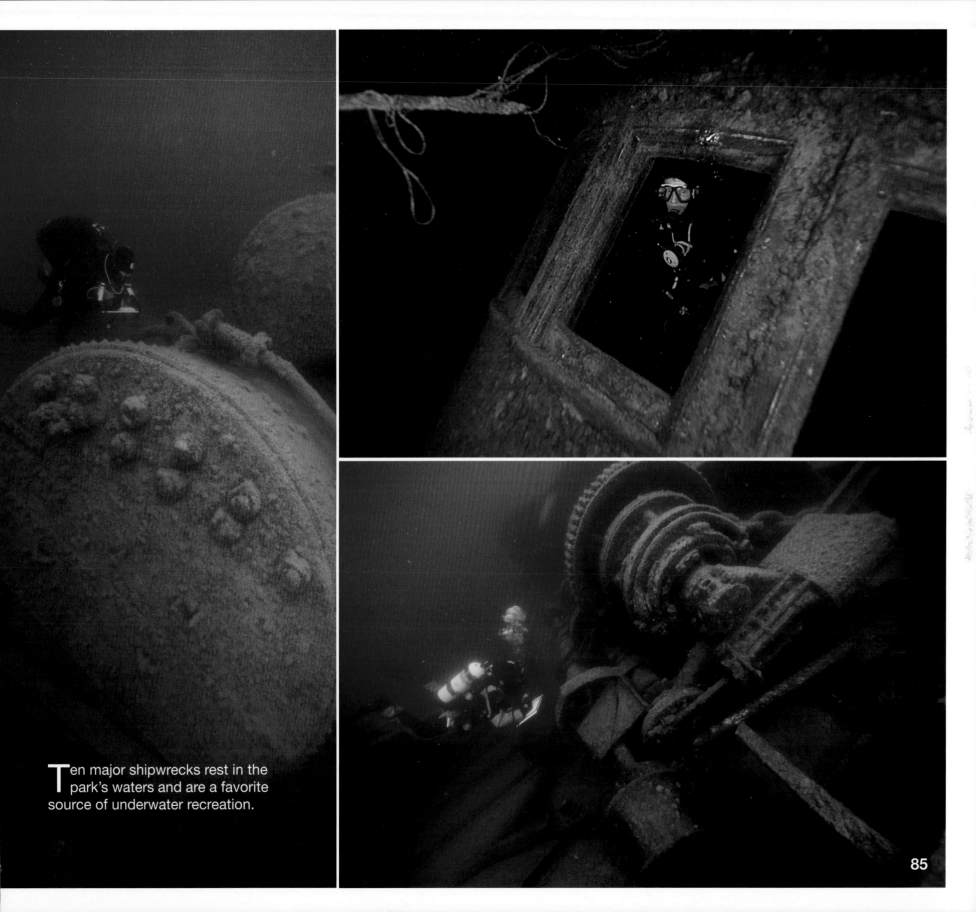

Ten major shipwrecks rest in the park's waters and are a favorite source of underwater recreation.

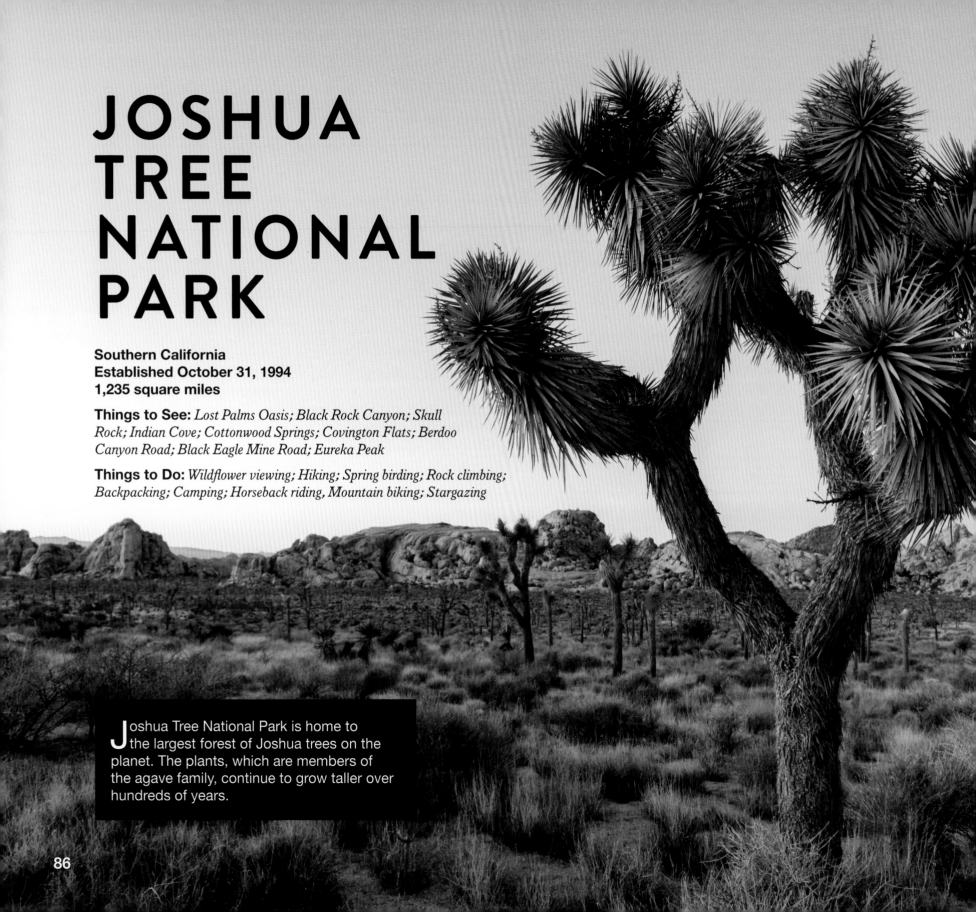

JOSHUA TREE NATIONAL PARK

Southern California
Established October 31, 1994
1,235 square miles

Things to See: *Lost Palms Oasis; Black Rock Canyon; Skull Rock; Indian Cove; Cottonwood Springs; Covington Flats; Berdoo Canyon Road; Black Eagle Mine Road; Eureka Peak*

Things to Do: *Wildflower viewing; Hiking; Spring birding; Rock climbing; Backpacking; Camping; Horseback riding, Mountain biking; Stargazing*

Joshua Tree National Park is home to the largest forest of Joshua trees on the planet. The plants, which are members of the agave family, continue to grow taller over hundreds of years.

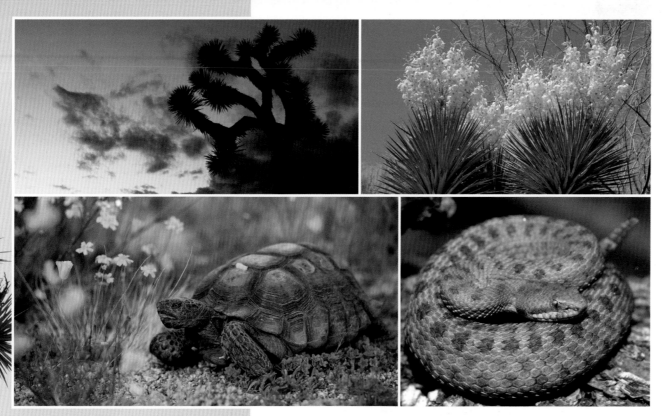

The surprising diversity of animal life in the park includes 250 kinds of birds, 52 species of desert mammals (primarily rodents), three amphibians (the tree frog and two types of toads), and 44 species of reptiles.

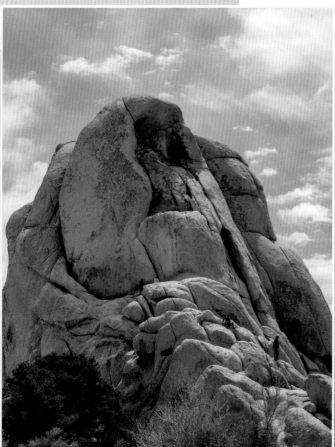

The Joshua tree forest is found in the Mojave Desert in the western half of the park, where one also finds the jumbled granite formations that have become so popular for rock climbing and bouldering.

KATMAI NATIONAL PARK AND PRESERVE

Southern Alaska
Established December 2, 1980
7,383 square miles

Things to See: *Valley of Ten Thousand Smokes; Brooks Falls; Novarupta Volcano; Brooks Camp; Savonski Loop*

Things to Do: *Sport-fishing; Canoeing and kayaking; Hunting; Camping; Hiking; Bear viewing*

The park, like all the Alaska national parks, is huge; at 7,383 square miles, it is the size of some small countries. The majority of the park—5,288 square miles—is designated wilderness area. The park takes its name from Mount Katmai, its crowning volcano; 6,716 feet in altitude, about six miles in diameter, its caldera roughly three miles by two miles in area. The park contains 15 active volcanoes, many still emitting steam from open vents and fissures.

Streams flowing from encircling mountains carved Katmai National Park and Preserve's stark Valley of Ten Thousand Smokes, filled with ash and pumice hundreds of feet deep, into spectacular gorges. Although a few plants have been able to gain a tenuous foothold here and there, the valley is essentially lifeless, a moonscape of desolation that looks as if it recently suffered a terrible catastrophe.

It did. Its great cataclysm occurred in 1912, when the Novarupta Volcano south of Iliamna Lake in southwestern Alaska erupted with a force that geologists believe was ten times greater than the explosion that took the top off Mount St. Helens in 1980. For hundreds of miles up and down the coast, the daylight sky was darkened by thousands of tons of ash thrown more than 30,000 feet into the sky. This volcano on the Alaska peninsula exploded as if a nuclear missile had struck the area, one of the three most powerful volcanic explosions ever recorded. The entire top of the mountain was violently blown off.

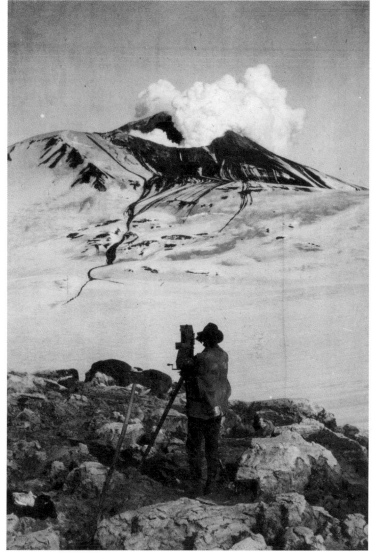

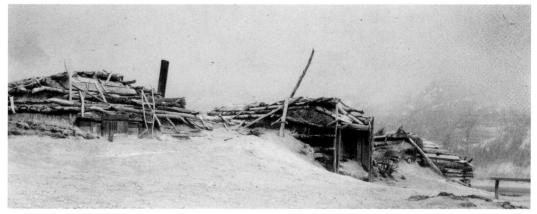

Today, Katmai is a wilderness wonderland of mountains, rivers, and forested valleys. The park is also famous for the immense congregations of Alaskan brown bears (up to 60 at one time) that gather on the Brooks Falls each summer to feed on sea-run salmon.

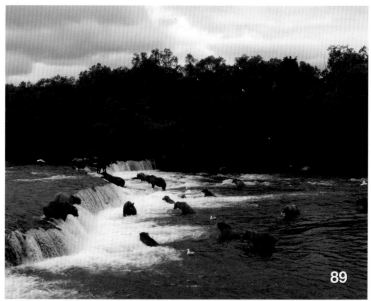

KENAI FJORDS NATIONAL PARK

Southeastern Alaska
Established December 2, 1980
1,050 square miles

Things to See: *Harding Icefield; Exit Glacier; Holgate Glacier; Three Hole Point*

Things to Do: *Hiking; Sea kayaking; Backpacking; Camping; Mountaineering; Sled dog touring, Sport-fishing; Cross-country skiing; Ice climbing*

This mammoth park covers almost 1,050 square miles, or 669,983 acres, of Alaska's wildest coast. The park's dynamic geology includes spectacular mountains with great glaciers flowing down between them to the sea, as well as awesome fjords that provide a habitat for thousands of nesting seabirds and seafaring mammals.

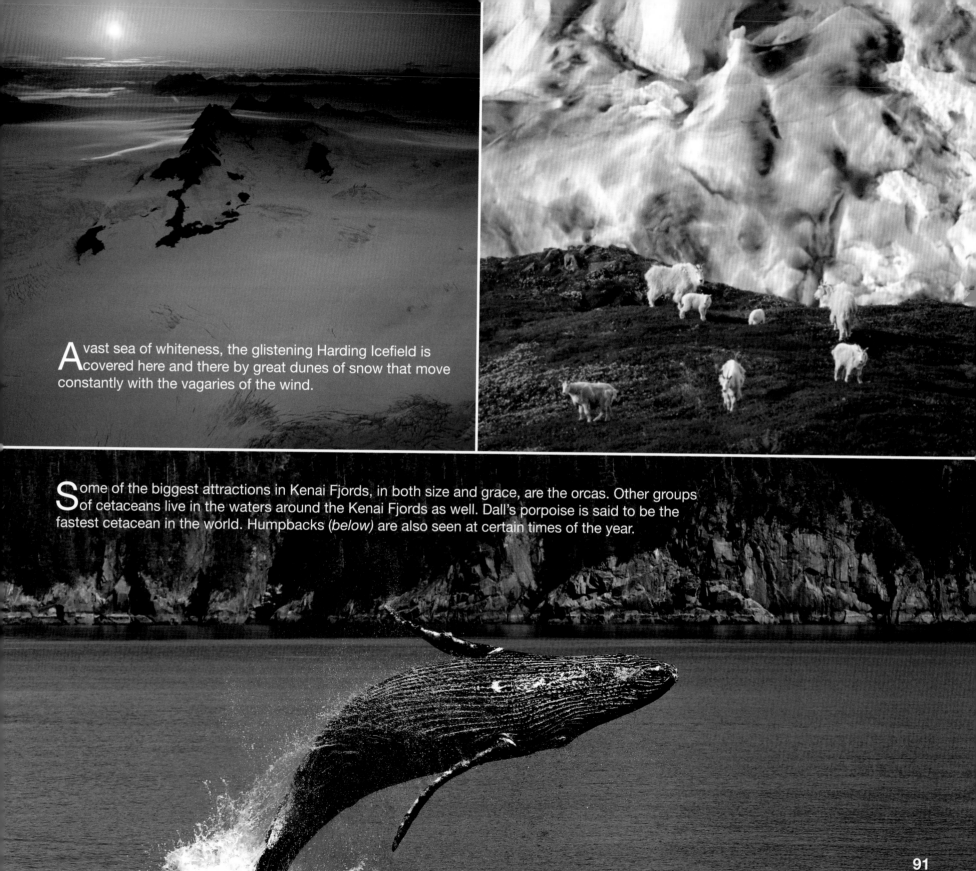

A vast sea of whiteness, the glistening Harding Icefield is covered here and there by great dunes of snow that move constantly with the vagaries of the wind.

Some of the biggest attractions in Kenai Fjords, in both size and grace, are the orcas. Other groups of cetaceans live in the waters around the Kenai Fjords as well. Dall's porpoise is said to be the fastest cetacean in the world. Humpbacks (*below*) are also seen at certain times of the year.

91

KOBUK VALLEY
NATIONAL PARK

Northern Alaska
Established December 2, 1980
2,750 square miles

Things to See: *Great Kobuk Sand Dunes; Onion Portage Archeological District; Kobuk River; Mount Angayukaqsraq*

Things to Do: *Hiking; Backpacking; Camping; Boating; Fishing; Wildlife watching*

Less than 40 miles west of Gates of the Arctic National Park, Kobuk Valley is pure Arctic terrain. Its wide bowl is filled with great boreal forests and a tundra that creeps up the lower slopes of the mountains.

Trudging through the vast, majestic, seemingly unending peaks of ice and snow that characterize most of Alaska, the last thing one expects to see is an expanse of sand dunes cresting to 100 feet. Visitors might stop in puzzlement and wonder when, exactly, they had been teleported to the Mojave Desert. This confusion would last only until a bitterly chill wind rushed through with a reminder that they were, indeed, above the Arctic Circle. As some of the only sand dunes above the Arctic Circle, these majestic anomalies are thought to be the remnants of a day long ago, when glacial melt rushed into the sandy bottoms of lakes and rivers. The dunes are vast and active, moving quickly and reaching summertime temperatures that top 100 degrees Fahrenheit. The Great Kobuk Sand Dunes today cover 23.5 square miles, but are believed at one time to have covered an area of perhaps 300 square miles.

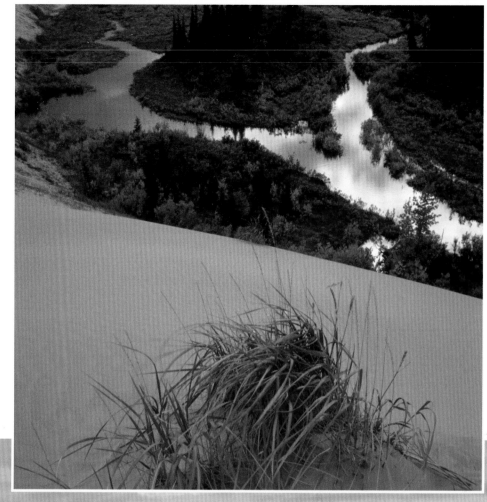

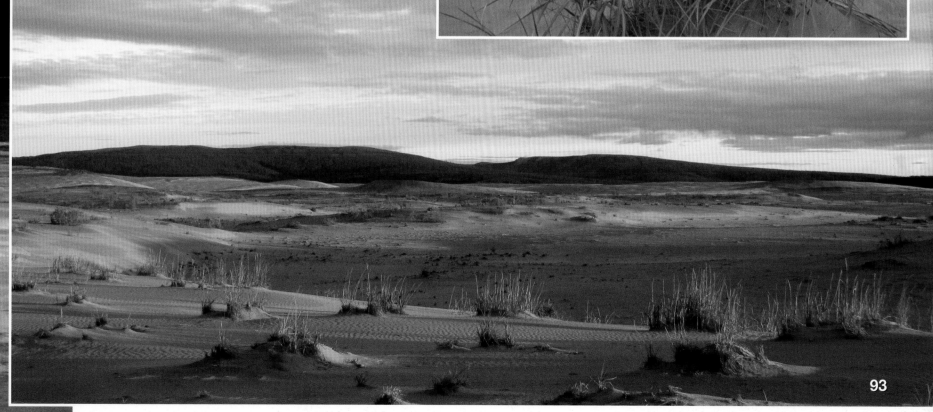

LAKE CLARK NATIONAL PARK AND PRESERVE

Southwestern Alaska
Established December 2, 1980
6,300 square miles

Things to See: *Redoubt volcano; Lake Clark; Ilamna volcano; Telaquana Lake; Port Alsworth; Tanalian Trail; Richard Proenneke Historic Site*

Things to Do: *Camping and backpacking; Kayaking and canoeing; Mountaineering; Hiking; Dog mushing; Fishing; Hunting; Backcountry skiing; Bird-watching; Rafting, Wildlife viewing, Rock climbing; Snowshoeing*

Take one pristine 42-mile-long lake, so clear that the salmon spawning in it can even be seen from an airplane. For wildlife, add grizzlies and huge brown bears, beluga whales and snowshoe hares. Include active volcanoes, major river systems, the collision of two major mountain ranges, tundra foothills, glacial valleys, river gravel bars, and old-growth forests, and what you have is "Essence of Alaska," a favorite nickname for Lake Clark National Park and Preserve.

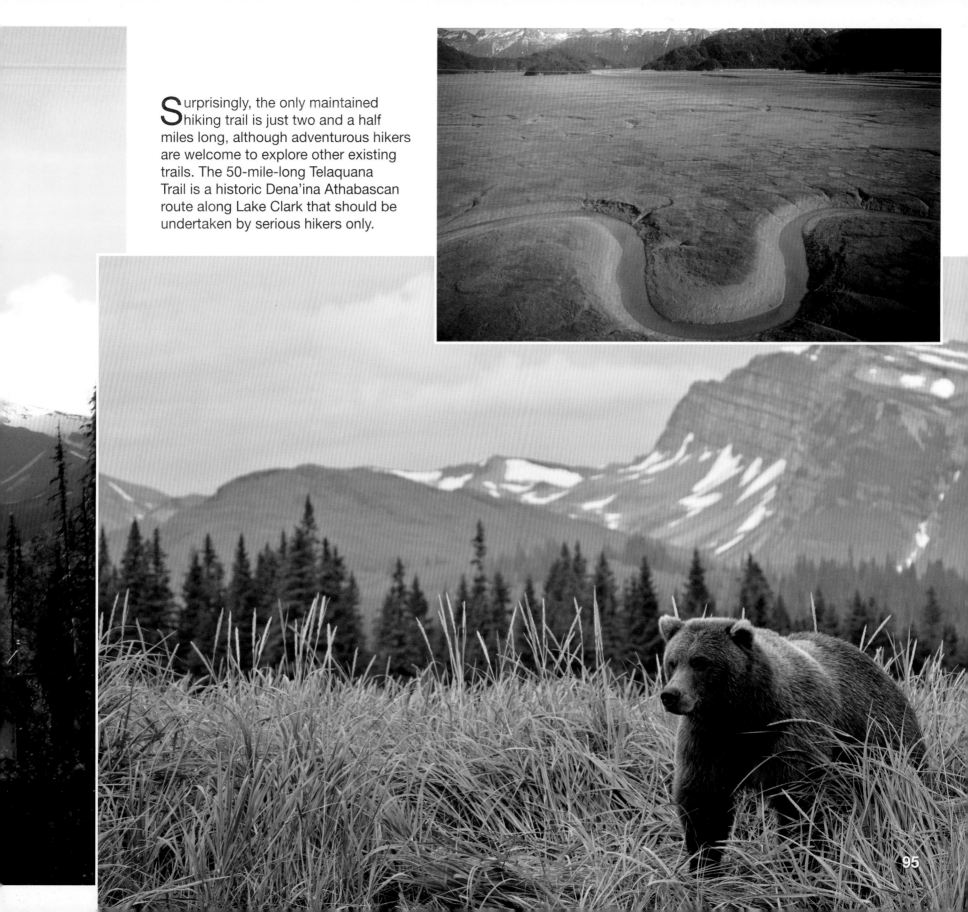

Surprisingly, the only maintained hiking trail is just two and a half miles long, although adventurous hikers are welcome to explore other existing trails. The 50-mile-long Telaquana Trail is a historic Dena'ina Athabascan route along Lake Clark that should be undertaken by serious hikers only.

95

LASSEN VOLCANIC NATIONAL PARK

Northeastern California
Established August 9, 1916
165 square miles

Things to See: *Lassen Peak; Manzanita Lake; Bumpass Hell; Boiling Springs Lake; Loomis Museum*

Things to Do: *Hiking; Camping; Boating and kayaking; Swimming; Horseback riding; Bird-watching; Snowshoeing and cross-country skiing in winter*

In May 1914, Lassen Peak, the largest plug dome volcano in the world, belched lava, steam, and ash, beginning a period of sustained eruptions that continued for a full seven years. The coup de grace was the blast on May 22, 1915, that resulted in a massive mushroom cloud, a 30,000-foot-tall apparition from the thermal underworld that could be seen hundreds of miles away.

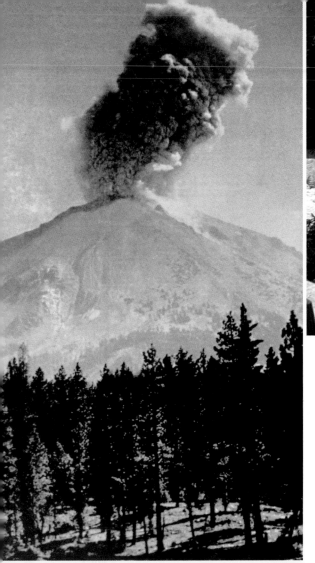

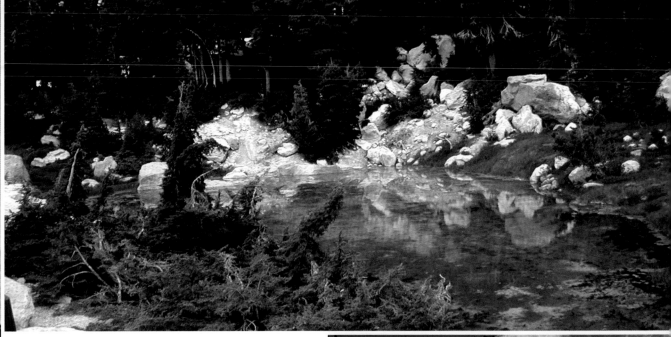

Since Lassen Peak's last eruption in 1921, the volcano has been dormant. Most of the park has been reclaimed by nature and presents a familiar northern California scene— aspen, firs, pines, willows, alders, poplar, shrubs, and wildflowers.

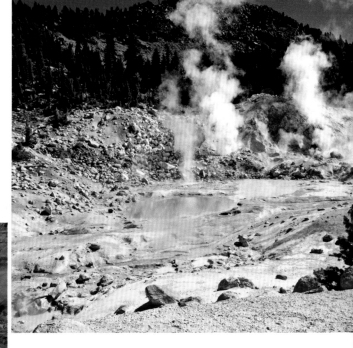

Like Yellowstone, Lassen Volcanic National Park is dotted with bubbling and steaming thermal features, powered by the interaction between the magma underground and the snowmelt that seeps through the cracks.

MAMMOTH CAVE NATIONAL PARK

Southern Kentucky
Established July 1, 1941
83 square miles

Things to See: *Natural entrance; Broadway Avenue; Bottomless Pit; Fat Man's Misery; Frozen Niagara; Drapery Room; Giant's Coffin; Tuberculosis huts; Star Chamber*

Things to Do: *Touring cave; Hiking; Canoeing; Horseback riding; Camping*

Mammoth Cave is the longest known cave system in the world by far. Hidden beneath the forests of southern Kentucky, this cave system has been explored for about 4,000 years. More than 360 miles of its underground passages have been explored—so far. New passages in the inconceivable labyrinth are constantly being found.

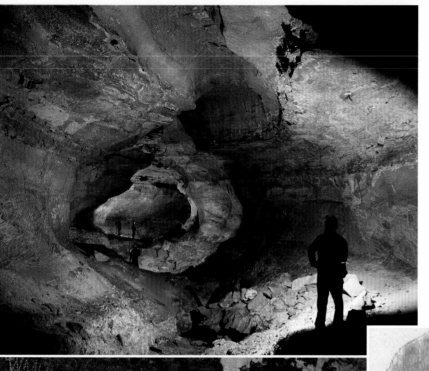

Mammoth Cave was formed, and is still being formed, by calcium carbonate, or limestone, which dissolves in water and seeps through the ground. Observed from the top down, then, Mammoth Cave consists of an upper layer of sandstone as thick as 50 feet in places, beneath which lies a series of limestone ridges. Sinkholes permit surface water to penetrate the upper sandstone, eroding the limestone as it seeps downward and forming stalagmites, stalactites, and columns at a rate of about one cubic inch every 200 years.

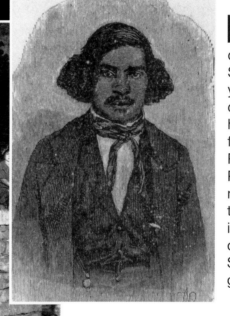

In 1838, entrepreneur Franklin Gorin bought the cave, planning to make it into a tourist draw using slaves as guides. Gorin introduced Stephen Bishop *(left)* to Mammoth Cave that year. Later, he wrote, "I placed a guide in the cave—the celebrated and great Stephen, and he aided in making the discoveries. He was the first person who ever crossed the Bottomless Pit. . . .After Stephen crossed the Bottomless Pit, we discovered all that part of the cave now known beyond that point. Previous to those discoveries, all interest centered in what is known as the 'Old Cave'…but now many of the points are but little known, although as Stephen was wont to say, they were 'grand, gloomy and peculiar.' "

Before Mammoth Cave became a national park, it offered a consumptive's room 160 feet underground, where high humidity soothed tuberculosis sufferers. This picture is from 1912.

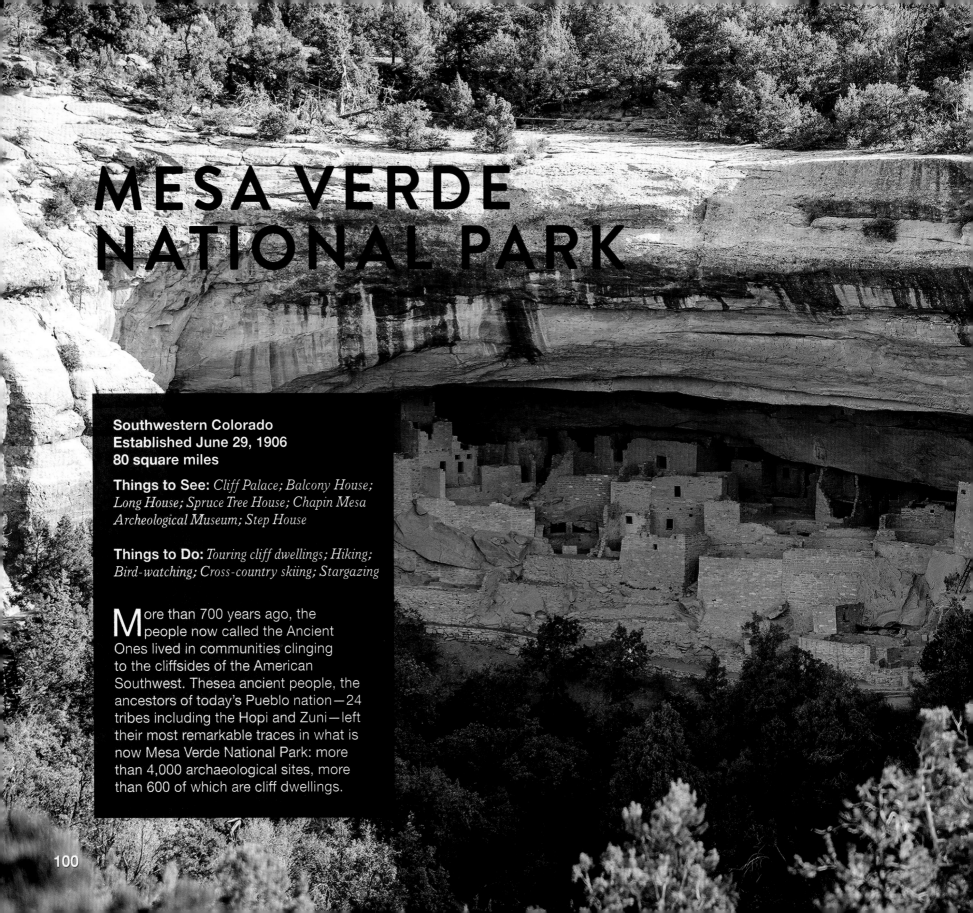

MESA VERDE NATIONAL PARK

Southwestern Colorado
Established June 29, 1906
80 square miles

Things to See: *Cliff Palace; Balcony House; Long House; Spruce Tree House; Chapin Mesa Archeological Museum; Step House*

Things to Do: *Touring cliff dwellings; Hiking; Bird-watching; Cross-country skiing; Stargazing*

More than 700 years ago, the people now called the Ancient Ones lived in communities clinging to the cliffsides of the American Southwest. Thesea ancient people, the ancestors of today's Pueblo nation—24 tribes including the Hopi and Zuni—left their most remarkable traces in what is now Mesa Verde National Park: more than 4,000 archaeological sites, more than 600 of which are cliff dwellings.

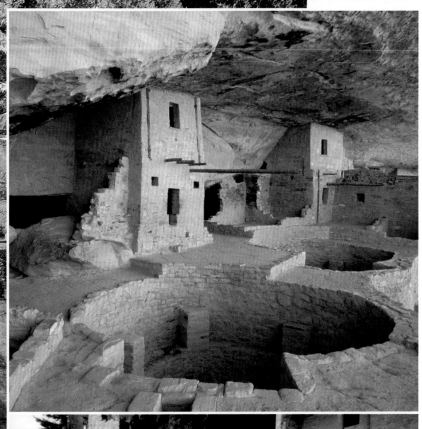

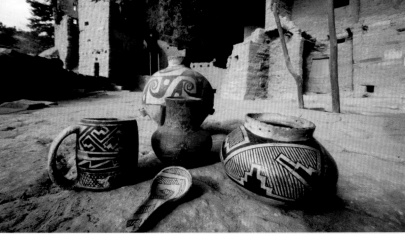

About 1,400 years ago, the Ancient Pueblos, living in the Four Corners region, migrated to Mesa Verde, where they resided for more than 700 years. Also called the Basketmakers, the Ancestral Puebloans settled Mesa Verde about AD 550. They had abandoned hunting and gathering, settling in pit-houses—which later evolved into kivas—in small villages. Most often these subterranean homes were built on mesa tops, although they were sometimes built into cliffs.

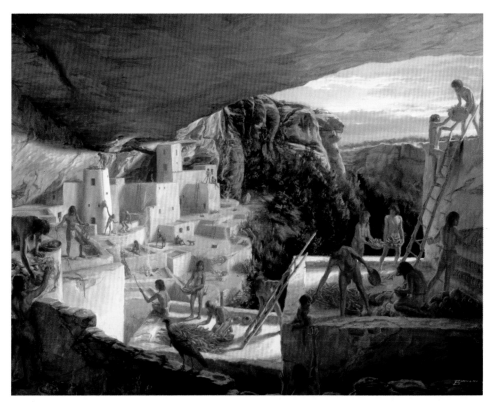

Late in their tenure, the Puebloans built complex stone villages in the alcoves of the canyon walls. But it took them only a generation—two at the most—to abandon their cliff homes. They had lived in their cliff dwellings for less than a century and had fled by AD 1300. Theories for their emigration abound. Some say the Ancients were hounded by drought and failed crops. Others believe they had overfarmed the land and underfed their livestock. Still others blame aggressive enemies. No one knows for certain why the Ancient Puebloans vanished or where they went.

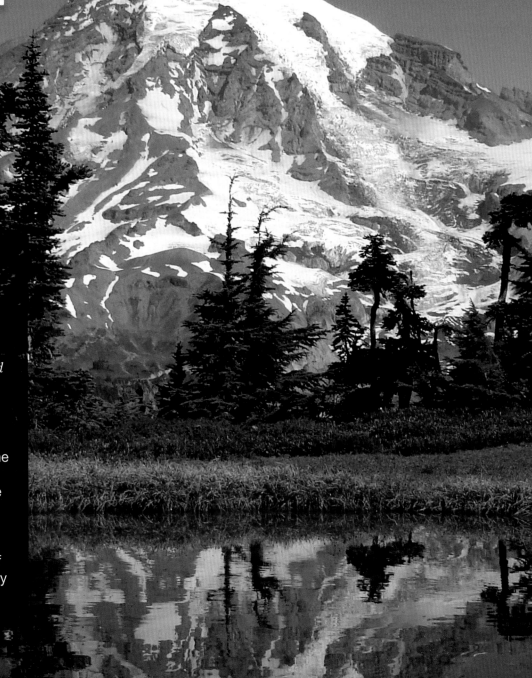

MOUNT RANIER NATIONAL PARK

Central Washington
Established March 2, 1899
370 square miles

Things to See: *Mount Rainier; Stevens Canyon; Longmire Museum; Wonderland Trail*

Things to Do: *Mountain climbing; Hiking; Fishing and boating; Camping; Skiing and snowboarding; Sledding*

When the "mountain is out" in Seattle, the seemingly omnipresent storm clouds part, and citizens can see the dominant mountain on the southeastern horizon: the indescribably majestic Mount Rainier. Although Mount Rainier itself is the park's most prominent feature, the national park offers many other attractions, both natural and manufactured. There is remarkable diversity to the different ecological zones at the wide range of elevations in the park. It follows that a great variety of plant and animal life finds refuge there.

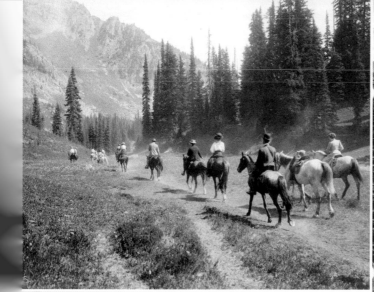

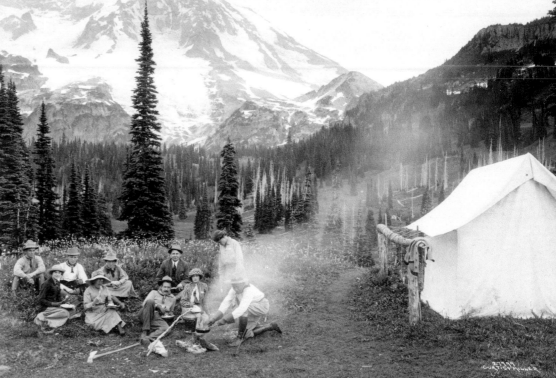

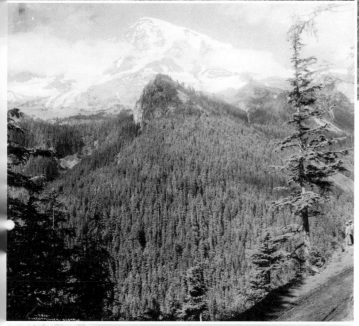

Mount Rainier is by no means an inactive volcano: It last erupted in the 1840s, and two significant eruptions have occurred in the past 2,500 years. Geologists expect that the volcano will erupt again in the future, after a warning sign in the form of a swarm of small earthquakes.

These historic photographs were taken in the early decades of the 1900s.

NORTH CASCADES NATIONAL PARK SERVICE COMPLEX

Northern Washington
Established October 2, 1968
1,075 square miles

Things to See: *Diablo Lake; Mount Logan; Mount Shuksan; Ross Lake; Forbidden Peak; Mount Redoubt; Gorge Lake; Gorge Creek Falls*

Things to Do: *Hiking; Climbing; Camping; Boating; Fishing; Backpacking; Bird and wildlife viewing; Horseback riding; Rafting*

An astonishing variety of ecosystems comprises Washington State's North Cascades National Park, with 9,000 feet worth of elevation change in the park and complex and radically different climates on either side of the divide. The varied life zones of this remote and vast wilderness combine into a greater whole that is one of the largest uninterrupted ecosystems in North America.

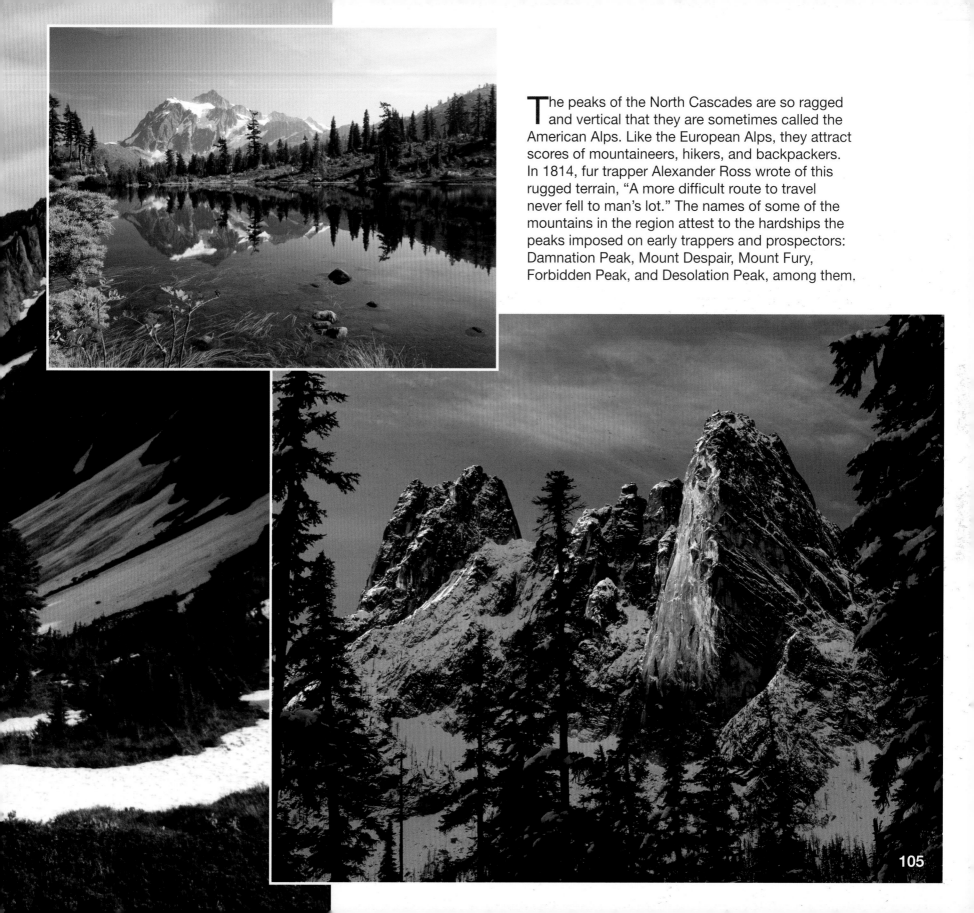

The peaks of the North Cascades are so ragged and vertical that they are sometimes called the American Alps. Like the European Alps, they attract scores of mountaineers, hikers, and backpackers. In 1814, fur trapper Alexander Ross wrote of this rugged terrain, "A more difficult route to travel never fell to man's lot." The names of some of the mountains in the region attest to the hardships the peaks imposed on early trappers and prospectors: Damnation Peak, Mount Despair, Mount Fury, Forbidden Peak, and Desolation Peak, among them.

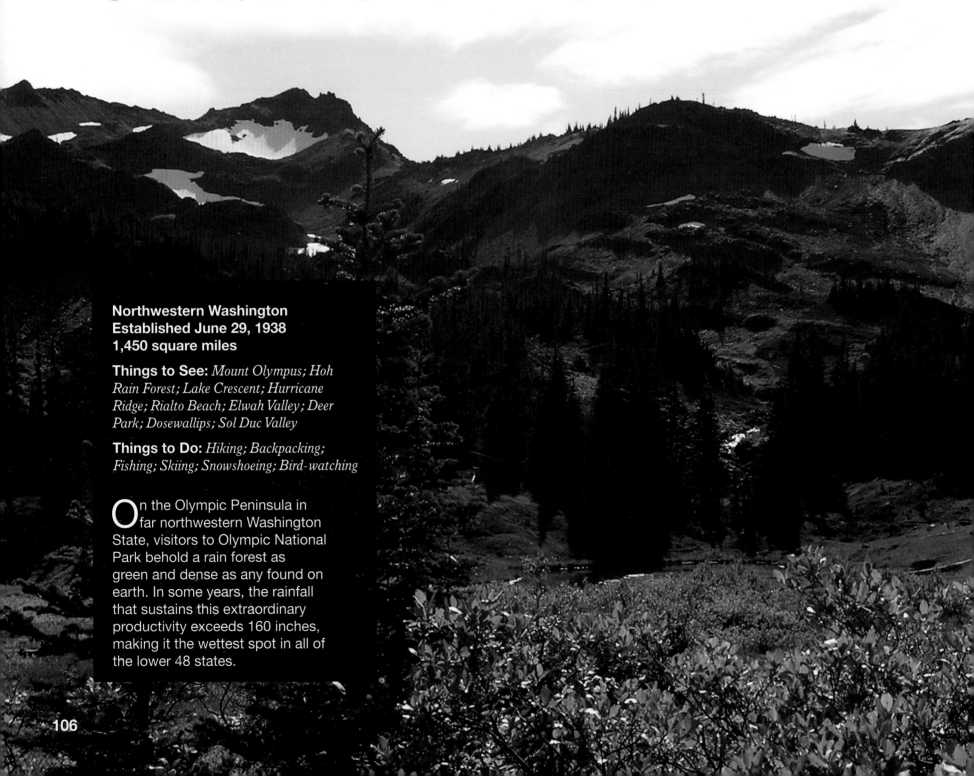

OLYMPIC NATIONAL PARK

Northwestern Washington
Established June 29, 1938
1,450 square miles

Things to See: *Mount Olympus; Hoh Rain Forest; Lake Crescent; Hurricane Ridge; Rialto Beach; Elwah Valley; Deer Park; Dosewallips; Sol Duc Valley*

Things to Do: *Hiking; Backpacking; Fishing; Skiing; Snowshoeing; Bird-watching*

On the Olympic Peninsula in far northwestern Washington State, visitors to Olympic National Park behold a rain forest as green and dense as any found on earth. In some years, the rainfall that sustains this extraordinary productivity exceeds 160 inches, making it the wettest spot in all of the lower 48 states.

This abundant rainfall is only part of the picture. Olympic is arguably the most diverse national park in the system. Along with the Hoh and three other rain forests (Quinault, Queets, and Bogachiel), the park contains a rugged wilderness seacoast, with headlands and beaches covered with driftwood, and the Olympic Mountains, a rugged range of high alpine meadows, great jagged ridges, and glaciers.

Because of this remarkably varied landscape, climatic changes within the park are unbelievably abrupt. The western side of the park has the wettest weather in the United States, averaging nearly 12 feet of precipitation each year. The eastern side of the park, however, which lies in the rain shadow of the mountains, is the driest area on the Pacific Coast north of Los Angeles.

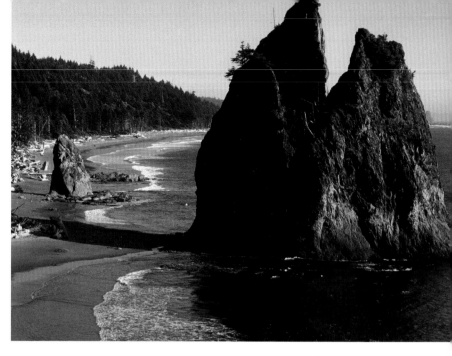

Vivid green landscapes once lined the coast from Oregon to Alaska, but logging and development have destroyed the vast majority of North American rain forests. The temperate rain forests in Olympic are among the few that remain in the world, let alone the country. But the rain forests are just one of several spectacular varieties of forest that are on display in Olympic. There are also montane and subalpine forests, featuring silver fir along with Douglas fir, mountain hemlock, and Alaska yellow cedar (including a world-record tree); coastal forests, with similar species as the rain forests interspersed with beaches and boggy coastal prairies; and lowland forests, primarily populated by western hemlock and Douglas fir.

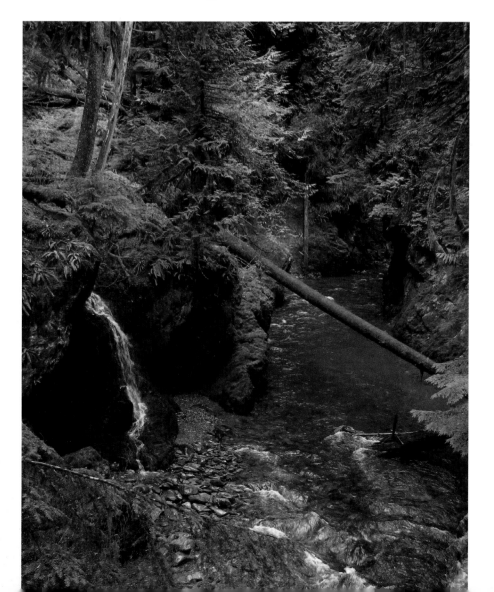

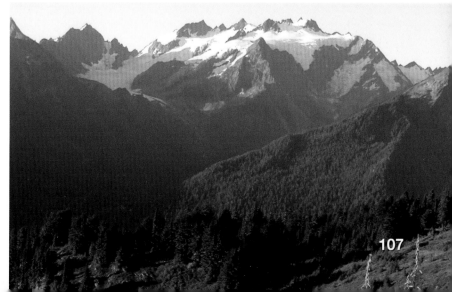

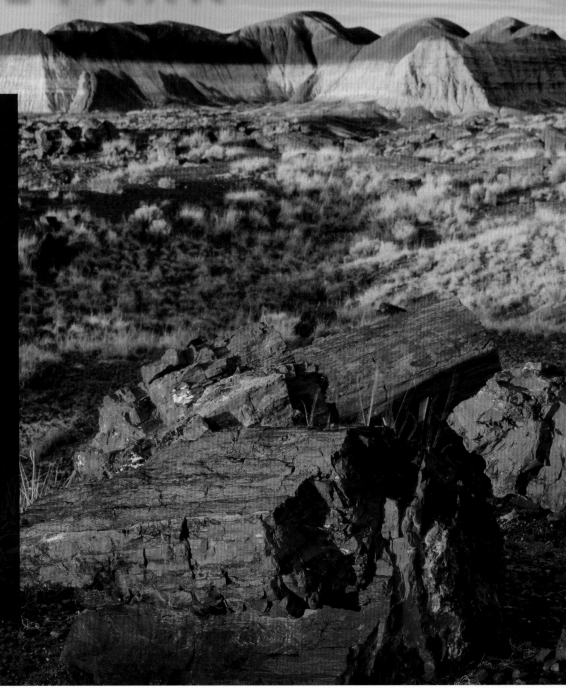

PETRIFIED FOREST NATIONAL PARK

Eastern Arizona
Established December 9, 1962
150 square miles

Things to See: *Kachina Point; Rainbow Forest Museum; Puerco Pueblo Trail; Giant Logs Trail; Painted Desert Rim; Blue Mesa; Crystal Forest; Long Logs; Agate House*

Things to Do: *Hiking; Camping; Backpacking; Horseback riding*

In eastern Arizona, the blistering sun scorches a mysterious stretch of bleached badlands. The forces of nature have carved a high plateau into a jumble of buttes, mesas, gullies, and cones, all tilted at unlikely angles. Another dimension is added to the mystery of this otherworldly scene by great hulking logs of stone clustered randomly on the ground, and scattered across the desert. Many of the logs are broken into segments so perfectly cut that they look like cordwood felled by a prehistoric giant. A closer look reveals that the logs' cross sections have glasslike surfaces that, just like the surrounding landscape itself, come in a rainbow of colors. These columns of petrified wood date from around 200 million years ago.

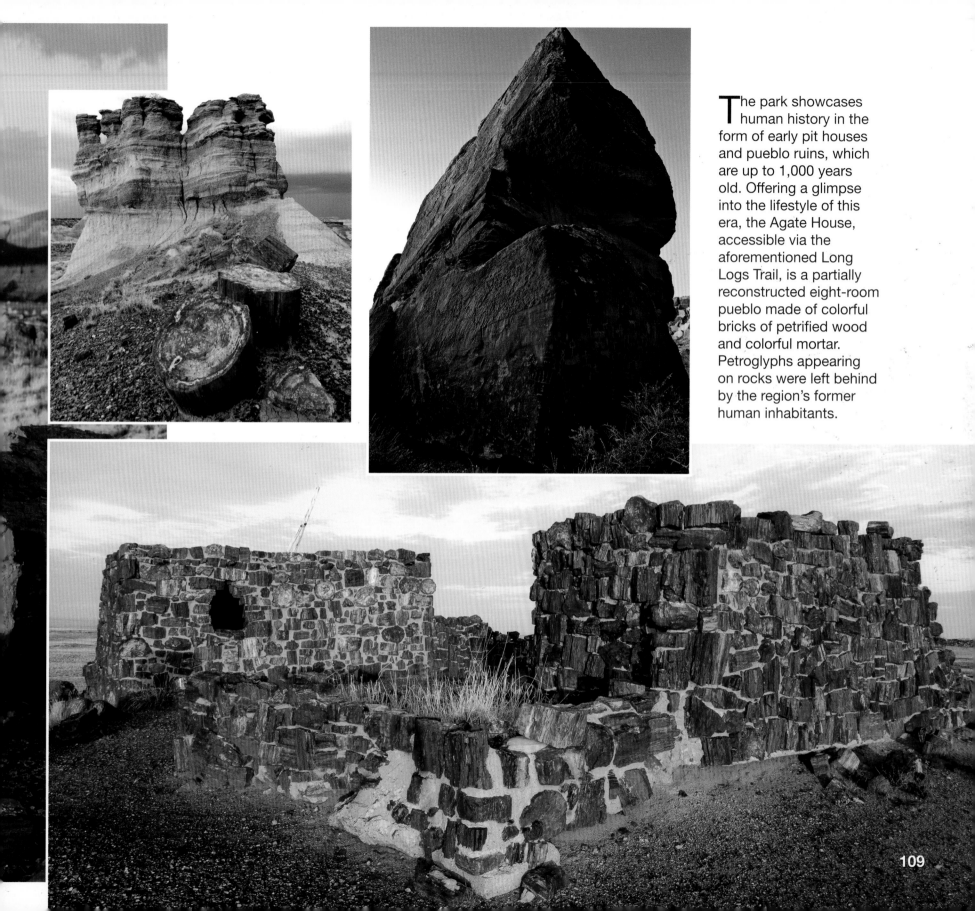

The park showcases human history in the form of early pit houses and pueblo ruins, which are up to 1,000 years old. Offering a glimpse into the lifestyle of this era, the Agate House, accessible via the aforementioned Long Logs Trail, is a partially reconstructed eight-room pueblo made of colorful bricks of petrified wood and colorful mortar. Petroglyphs appearing on rocks were left behind by the region's former human inhabitants.

PINNACLES NATIONAL PARK

Central California
Established January, 10 2013
1.5 square miles

Things to See: *Talus caves; High Peaks Trail; Balconies Cave; Bear Gulch*

Things to Do: *Hiking; Rock-climbing; spotting condors*

Not far from the San Andreas fault, Pinnacles National Park has been shaped by geologic activity. Volcanic activity from millions of years ago has left its mark on the landscape today, producing the rock formations that inspired the park's name. Geological activity and erosion have created fascinating, surreal

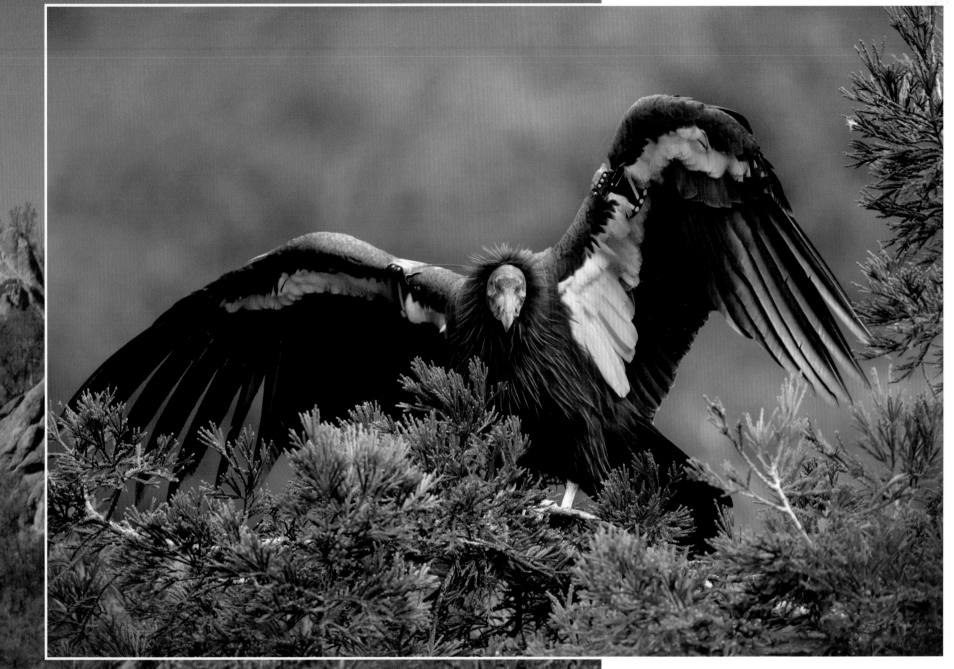

After Condor numbers plummeted in the 1980s, they have rebounded due to captive breeding programs. Pinnacles National Park is one of the locations where captive-bred condors are released into the wild.

REDWOOD NATIONAL AND STATE PARKS

Northwestern California
Established October 2, 1968
175 square miles

Things to See: *Klamath River Overlook; Coastal Trail; Redwood Creek Trail; Tall Trees Grove; High Bluff Overlook; Lady Bird Johnson Grove; Elk Meadow*

Things to Do: *Hiking; Bird-watching; Horseback riding; Kayaking; Bicycling*

Sightseers crane their gaze upward at skyscraping treetop after skyscraping treetop, a vast and misty sea of coastal redwood forest that dominates the landscape near the rocky Pacific shore, just south of the California-Oregon border. Visitors to this primeval place get a sense of scale that's like something out of Alice's journey through the looking glass: This is a forest of startlingly immense proportions. Human beings look like miniature toy figures next to these great trees, known to botanists as *Sequoia sempervirens,* that soar 30 stories or more into the sky, higher than any other living things on the planet.

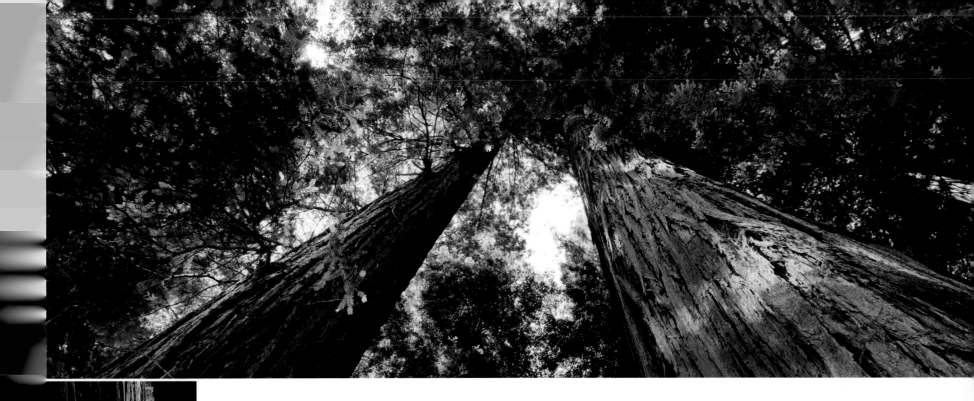

To put their height in perspective, the tallest coast redwoods in the park are taller than the Statue of Liberty, including the torch and the base, topping out over 370 feet. The first branches of these trees begin 100 to 200 feet above the spongy forest floor, forming a delicate green canopy that pushes the blue sky even higher than it usually seems in the West. California's mighty redwood trees, many now living in their second millennia, are the last large stands of these monumental conifers that flourished all across North America during the lush, humid period before the last Ice Age.

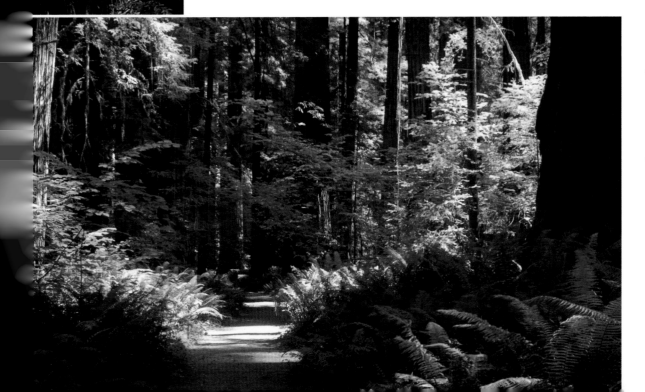

Scientists have only recently begun to understand the complex ecosystem of these ancient redwood forests. The branches that form the canopy at the top of the redwoods eventually fall to earth, where they mix with leaves and branches from hemlock and other species and eventually decay. This process sustains a rich web of life, where many interdependent species of plants and animals are tightly woven into the greater ecosystem.

ROCKY MOUNTAIN NATIONAL PARK

Northern Colorado
Established January 26, 1915
415 square miles

Things to See: *Longs Peak; Glacier Gorge; Trail Ridge Road; Kawuneeche Valley Sprague Lake; Old Falls River Road; Grand Lake; Bear Lake; Glacier Basin; Lava Cliffs; West Basin*

Things to Do: *Climbing and mountaineering; Fishing; Hiking; Backpacking; Camping; Biking; Skiing and snowshoeing*

Rocky Mountain National Park is high country, with sweeping vistas of a jagged skyline crowned by towering summits. Snow lingers here year-round, and the highest cirques preserve remnants of glaciers left over from the last Ice Age. Within the park are 78 peaks greater than 12,000 feet tall; 20 of them reach above 13,000 feet. Contrasting with this jagged terrain, meadows come alive in spring and summer as wildflowers poke their way through the tundra.

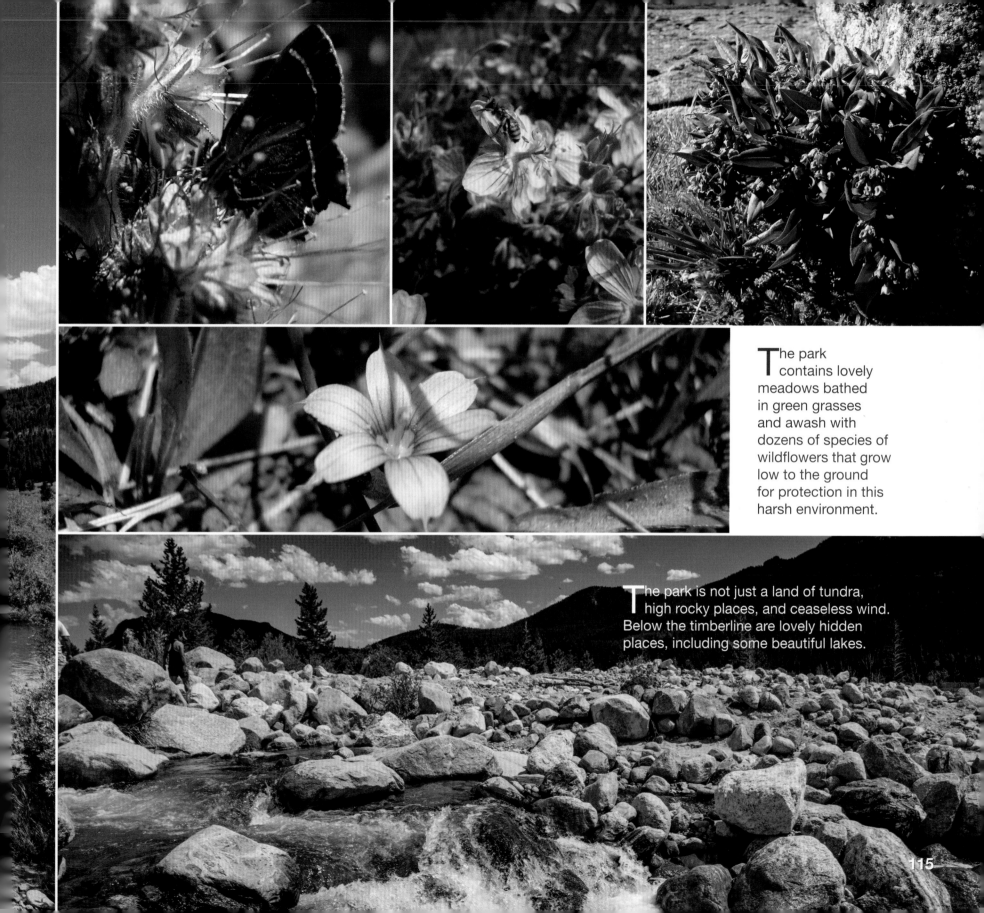

The park contains lovely meadows bathed in green grasses and awash with dozens of species of wildflowers that grow low to the ground for protection in this harsh environment.

The park is not just a land of tundra, high rocky places, and ceaseless wind. Below the timberline are lovely hidden places, including some beautiful lakes.

"Of all the large and rugged mountain ranges in the world, these are the most friendly, the most hospitable," wrote pioneer naturalist Enos Mills, who was instrumental in the creation of Rocky Mountain National Park in 1915.

Photos taken between 1902 and 1936

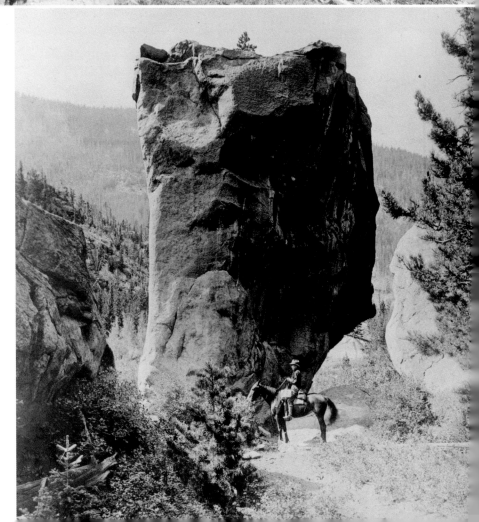

SAGUARO NATIONAL PARK

Southeastern Arizona
Established October 14, 1994
142 square miles

Things to See: *Rincon Creek Trail; Spud Rock; Douglas Spring Trail; Wildhorse Canyon; Cactus Forest Drive; Scenic Bajada Loop Drive; Valley View Overlook*

Things to Do: *Hiking; Desert flora viewing; Bicycling*

One of the few national parks in the system that's located on the doorstep of a sizable city, Saguaro National Park calls Tucson, Arizona, neighbor. Established in 1933 and designated a national monument within the past 20 years, Saguaro was designated a park in just 1994. The park preserves an amazing forest of stately giant saguaro cacti, interspersed with other Sonoran Desert flora, such as hedgehog cactus, fishhook barrel cactus, cholla, ocotillo, and prickly pear.

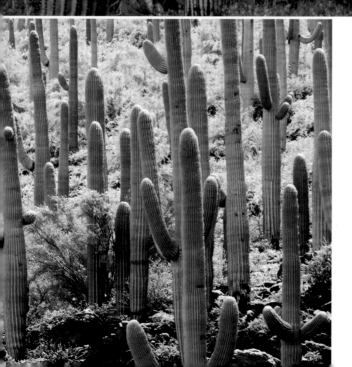

The majestic saguaro cacti are long-lived, slowly growing to heights sometimes in excess of 40 feet over the course of their 150 to 200 years. They grow an inch a year during their first years and can take 65 years or more to develop their first side arm; an adult cactus with a triumphant pair or trio of arms reaching skyward is likely 125 years old. Conversely, the saguaro's spines grow very quickly, up to a millimeter per day. The park boasts one of the largest concentrations of giant saguaro anywhere, with an estimated 1.6 million specimens rooted on park land.

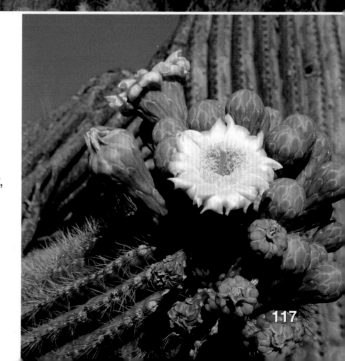

SEQUOIA AND KINGS CANYON

Eastern central California
Sequoia National Park established September 25, 1890; Kings Canyon
National Park established March 4, 1940
1350 square miles (combined)

Things to See: *Mount Whitney; Kings Canyon; General Sherman sequoia; Giant Forest Museum; Centennial Stump; Kings River; Big Stump Trail; Ash Mountain*

Things to Do: *Hiking; Horseback riding; Skiing; Rock Climbing; Sequoia viewing*

Whether large or microscopic, the size and scale of the natural wonders of the country's national parks often help visitors put their lives into better perspective. In central California, Sequoia and Kings Canyon National Parks—adjacent parks administered jointly since 1943—offer perspective on the large end of the spectrum—the very large. The parks contain numerous groves of the planet's largest living things, giant sequoia trees that are so huge they far surpass the size of any other species.

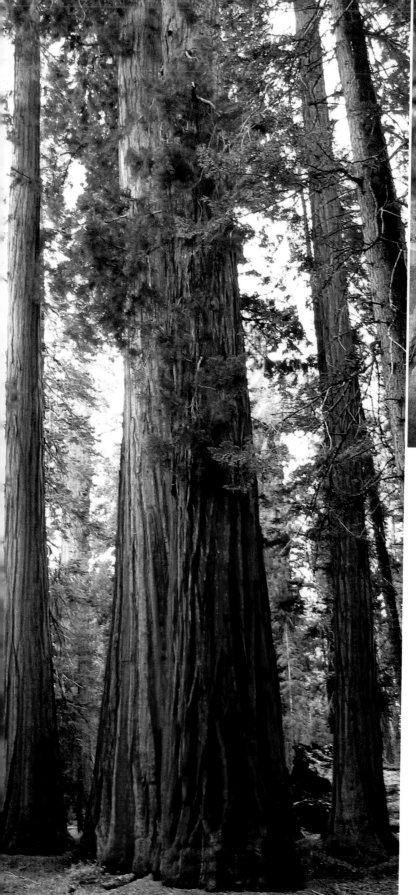

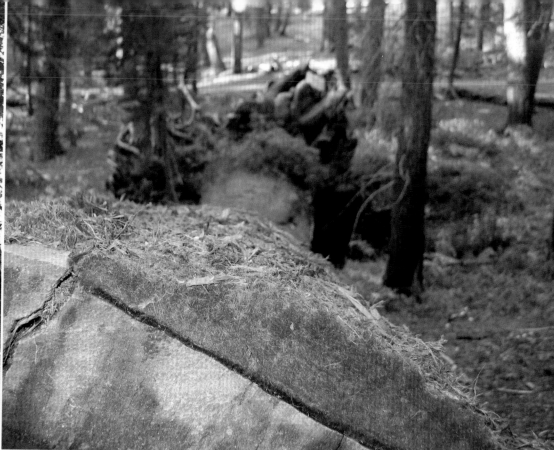

The largest trees by weight and volume in the world, the sequoias in this park are the last relics of a species that covered much of the world before the most recent ice age. The glaciers swept over all but a few thousand acres too high in the Sierra Nevada for the ice to reach, destroying all the trees in their path.

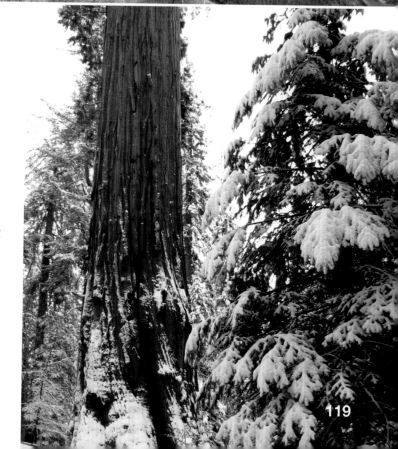

119

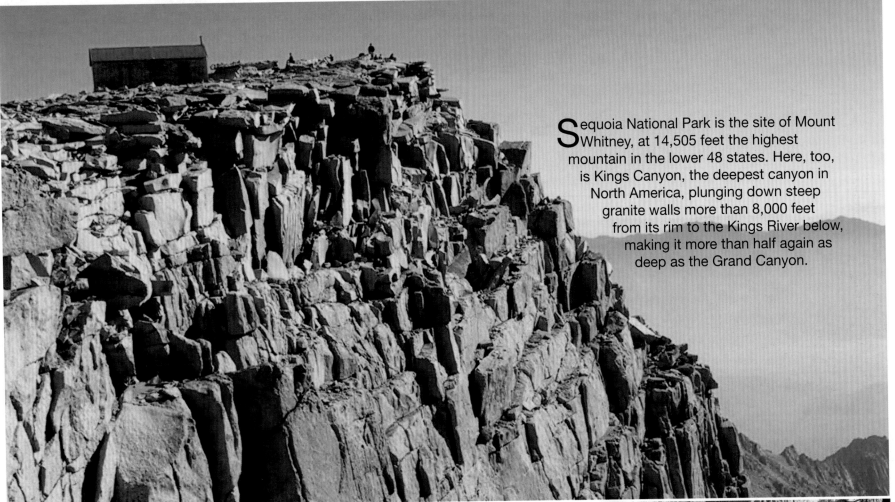

Sequoia National Park is the site of Mount Whitney, at 14,505 feet the highest mountain in the lower 48 states. Here, too, is Kings Canyon, the deepest canyon in North America, plunging down steep granite walls more than 8,000 feet from its rim to the Kings River below, making it more than half again as deep as the Grand Canyon.

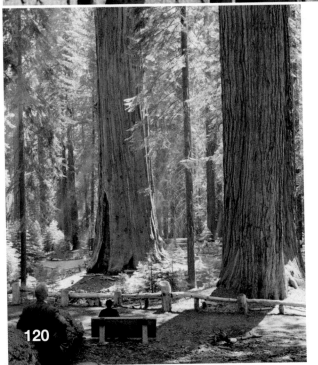

Logging of what was then one of the world's finest and most extensive old-growth forests began in about 1862 and continued relentlessly until the turn of the century. Vast stands of these giant trees were wiped out, including at least two trees, and possibly as many as four, that were bigger than the biggest tree in the world today, the park's famed General Sherman sequoia, said to be the largest living tree on the planet (The Sherman Tree group is shown here in 1950).

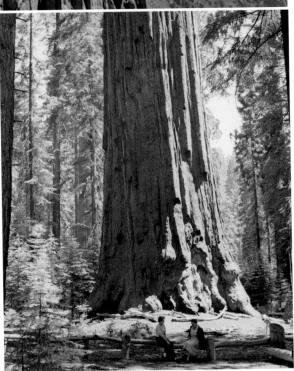

SHENANDOAH NATIONAL PARK

Northern Virginia
Established December 26, 1935
310 square miles

Things to See: *Lewis Mountain; Big Meadows; Skyline Drive; Loft Mountain*

Things to Do: *Hiking; Camping; Bird-watching; Wildlife viewing; Fishing; Bicycling*

Shenandoah National Park spans 199,100 acres and rises to 4,051 feet at Hawksbill Mountain, one of two peaks more than 4,000 feet high. It boasts 500 miles of hiking and climbing trails, including 101 miles of the Appalachian Trail. The park is uplifted over the Virginia Piedmont on the east and the Shenandoah Valley on its west. Some of the most satisfying hikes in America are found here.

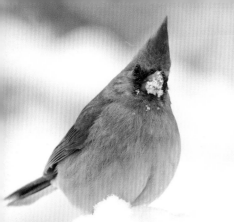

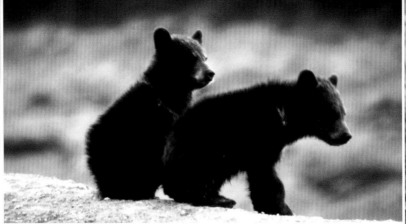

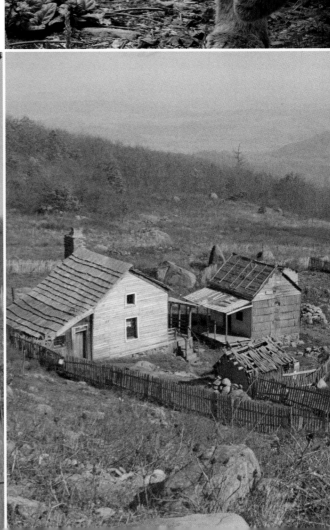

More than 50 species of mammal inhabit Shenandoah, from the big brown bat to striped and spotted skunks, and from tiny moles, voles, and shrews to bobcats, bears, coyotes, and cougars. Most famed of the park's animals are its American black bears. One of the densest populations of black bears in the United States takes refuge here.

The park's origins were somewhat controversial. Congress authorized Shenandoah National Park in 1926, after the Southern Appalachian National Park Committee, a group of scientists and park planners, had scoured the Appalachian and Blue Ridge mountains for the most suitable site. In the end, they decided that there was no choice but to evict the families remaining in the park. Five hundred or so families, about 2,500 people in all, were uprooted in the process, leaving behind a number of abandoned settlements.

Most people left quietly. A few of those who resisted eviction were permitted to stay. The park's last resident was Annie Lee Bradley Shenk, who died in 1979 at age 92. These images of the Corbin household were taken in 1935.

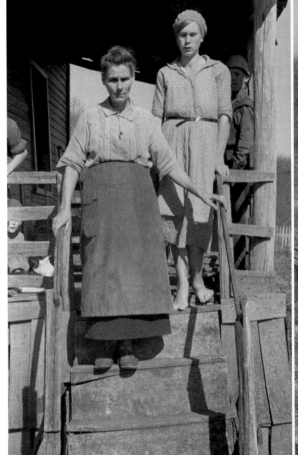

THEODORE ROOSEVELT NATIONAL PARK

Western North Dakota
Established November 10, 1978
110 square miles

Things to See: *Elkhorn Ranch; Maltese Cross Cabin; Little Missouri River Badlands*

Things to Do: *Hiking; Camping; Horseback riding; Bicycling; Canoeing and kayaking; Cross-country skiing; Fishing; Snowshoeing; Wildlife viewing*

Theodore Roosevelt National Park comprises more than 70,000 acres including almost 30,000 wilderness acres. The history of North Dakota's badlands and prairie goes back at least 65 million years, after the Rocky Mountains arose over the Great Plains and just after the dinosaurs became extinct. For 50 million years streams and winds eroded the mountains, carrying their sediment across the plains. Then, between five million and ten million years ago, the Great Plains uplifted, and the Little Missouri River began to scour the Badlands and create the towering cliffs, twisted gullies, domelike hills, and rugged pinnacles like needles, all daubed with colored striations that run on for miles. It is, as Roosevelt himself said, "a chaos of peaks, plateaus, and ridges."

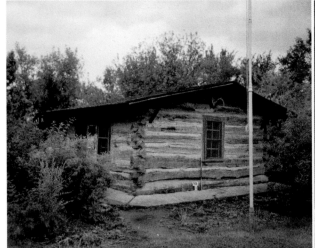

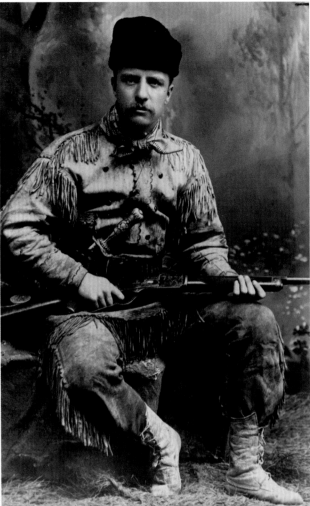

Theodore Roosevelt once said, "I would never have been President if it had not been for my experiences in North Dakota," namely the North Dakota Badlands area now memorialized as his namesake national park. Roosevelt first visited the Badlands in 1883 to hunt buffalo. The next year his wife and mother died on the same day. Roosevelt very deliberately headed to North Dakota to both salve his grief and salvage his health, which suffered from asthma. While at the Badlands, Roosevelt found the proverbial "new lease on life." The influence the Badlands had on the young Roosevelt later translated into historic change. Roosevelt saw the destruction of the bison with his own eyes, which caused him to become a conservationist who was responsible for creating 150 national forests, 51 wildlife refuges, 18 national monuments, and five national parks.

Animal- and bird-watching are popular park pastimes. Bison roam throughout the park—and should receive a wide berth if met along the trail. Mule deer most often are to be seen between dusk and dawn, and in daytime in open areas in the shade of dense juniper groves. White-tailed deer seek thick woods and river bottom lands. Elk and feral horses can be seen in the South Unit.

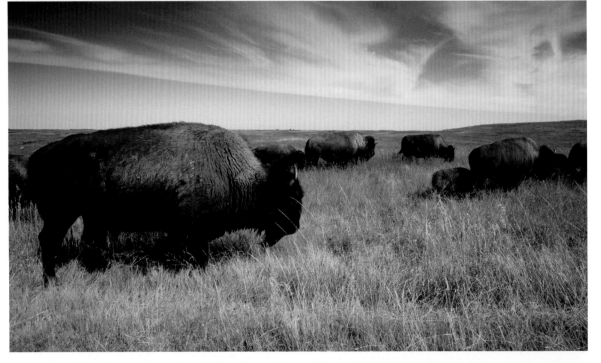

VIRGIN ISLANDS NATIONAL PARK

U.S. Virgin Islands
Established August 2, 1956
23 square miles

Things to See: *Trunk Bay; Hawksnest Bay; Annaberg Sugar Mill; Cinnamon Bay; Reef Bay; Catherineberg Sugar Mill*

Things to Do: *Snorkeling; Swimming; Sailing; Hiking; Kayaking; Scuba diving; Windsurfing; Camping; Bird-watching*

Within the borders of Virgin Islands National Park are some 9,000 acres of spectacular Caribbean beaches, forests, and mountains, as well as 5,650 undersea acres and several stunning underwater nature trails. Located west of Puerto Rico near the confluence of the Caribbean and the Atlantic Ocean, the park encompasses approximately 60 percent of St. John, the third largest of the U.S. Virgin Islands, as well as a few parcels on St. Thomas, to the west of St. John. Here visitors will find an incredible diversity of plant life, owing to a huge amount of annual rainfall, as well as the island's exposure to seed-bearing winds.

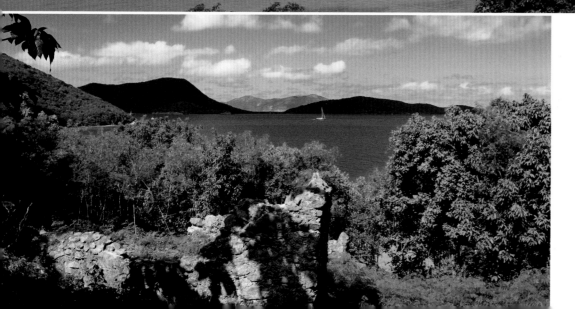

Wandering through high-elevation subtropical forests in the park's interior, visitors can see more than 800 plant species. At lower elevations, there are dry, desertlike areas, as well as mangrove swamps rich with mango trees, palms, soursops, peeling red "tourist trees" that smell like turpentine, vibrantly blooming flamboyant trees, and century plants.

VOYAGEURS NATIONAL PARK

Northern Minnesota
Established January 8, 1971
340 square miles

Things to See: *Kabetogama Lake; Boundary Waters Canoe Area; Oberholtzer Trail; Rainy Lake; Little American Island; Kettle Falls*

Things to Do: *Camping; Canoeing; Hiking; Fishing; Cross-country skiing; Wildlife viewing; Snowshoeing; Ice fishing*

Voyageurs National Park is the rare roadless national park and the only park where a canoe can be a travel necessity. The park pays historic tribute to the Voyageurs, fur trappers and traders required to work 14 or more hours per day, portage—carry over land—26-foot canoes with 180 pounds or more worth of goods, and sometimes paddle at a rate of almost one stroke per second. Today, the park's nearly 220,000 acres are accessible only by waterway; nonetheless about a quarter-million visitors come yearly.

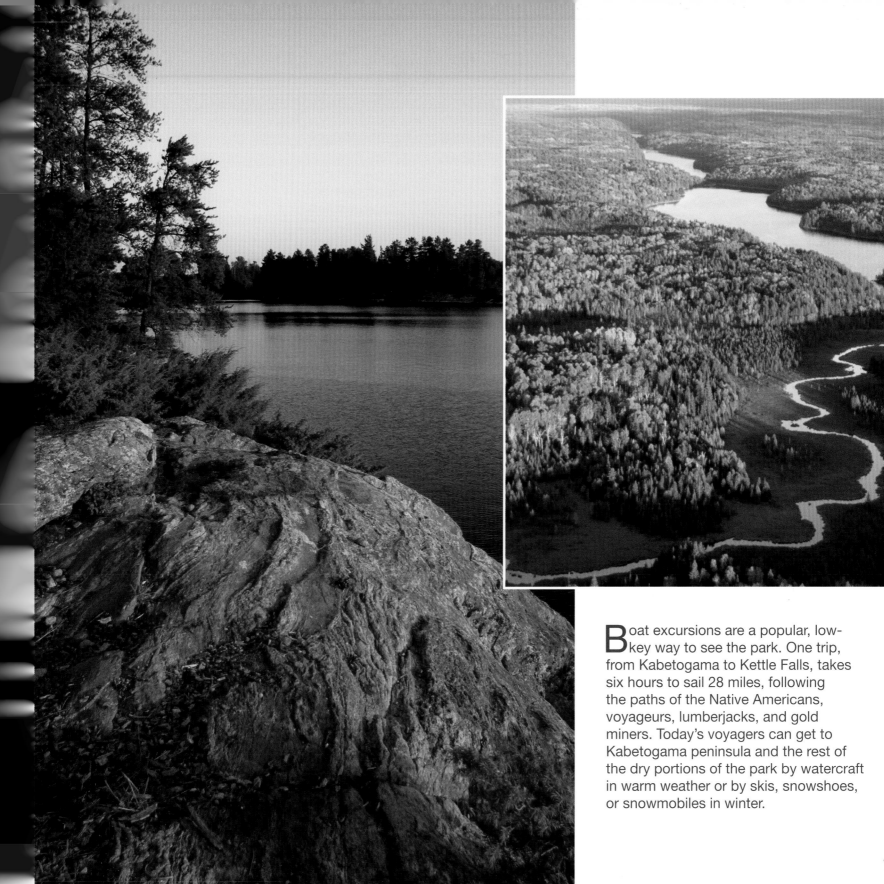

Boat excursions are a popular, low-key way to see the park. One trip, from Kabetogama to Kettle Falls, takes six hours to sail 28 miles, following the paths of the Native Americans, voyageurs, lumberjacks, and gold miners. Today's voyagers can get to Kabetogama peninsula and the rest of the dry portions of the park by watercraft in warm weather or by skis, snowshoes, or snowmobiles in winter.

WIND CAVE NATIONAL PARK

Southwest South Dakota
Established January 9, 1903
5 square miles

Things to See: *Wind Cave; Centennial Trail; Lookout Tower; Rankin Ridge Trail*

Things to Do: *Cave Tours; Hiking; Backcountry camping; Horseback riding*

Due west of Badlands National Park, due east of Jewel Cave National Monument, ten miles north of Hot Springs, South Dakota, lies the world's fourth-longest cave and perhaps the most tantalizing, intriguing, and purely beautiful of them all: Wind Cave. Wind Cave is among the world's oldest caves: Parts of it date back more than 300 million years. It also is considered a three-dimensional cave in that it has multiple vertical stories as well as its great horizontal extent—all 129 miles of explored cave passages exist within a single square mile at surface area. And it is the cave with the world's greatest collection of boxwork, thin fin-shaped calcite formed

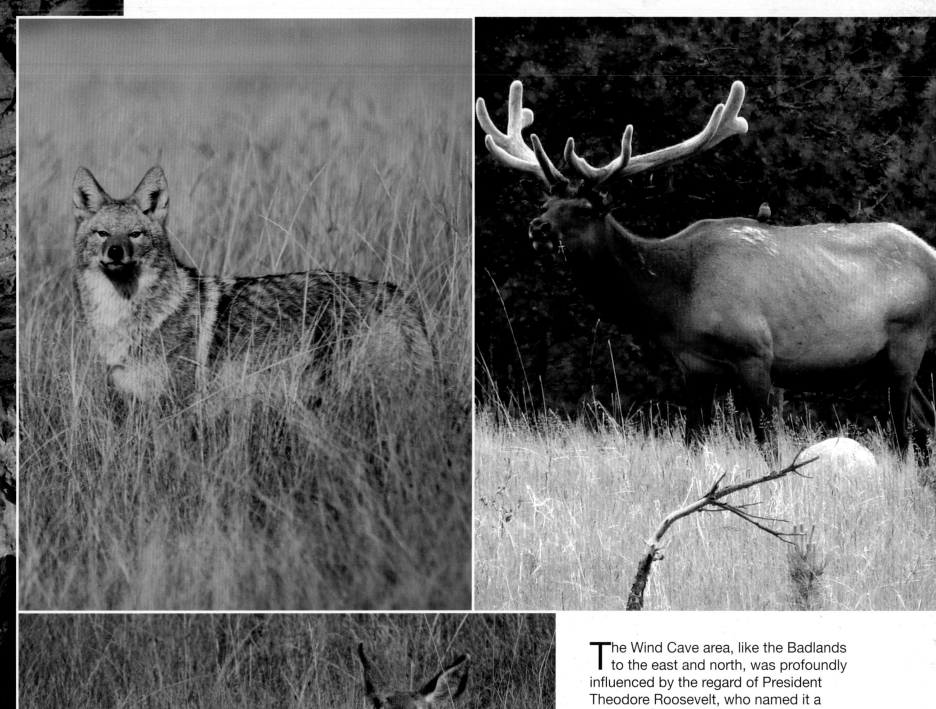

The Wind Cave area, like the Badlands to the east and north, was profoundly influenced by the regard of President Theodore Roosevelt, who named it a national park in 1903, the first cave to be so named. Atop Wind Cave National Park lie 28,295 acres of ponderosa pine forest and mixed-grass prairie, home to bison (including one of the last genetically pure herds), pronghorn, mule deer, and elk.

WRANGELL–ST. ELIAS NATIONAL PARK AND PRESERVE

Southeastern Alaska
Established December 2, 1980
20,587 square miles

Things to See: *Mount St. Elias; Mount Wrangell; Nabesna Glacier; Copper River; Malaspina Glacier; Hubbard Glacier; Bagley Icefield; Liberty Falls Trail; Kennecott Mines National Historic Landmark*

Things to Do: *Hiking; Mountain biking; Fishing; Hunting; Backpacking; Sea kayaking; Mountaineering*

Three great mountain ranges converge in Wrangell–St. Elias National Park and Preserve, creating a reckless jumble of ragged peaks, lovely river valleys, and enormous glaciers. The St. Elias Mountains, the world's tallest coastal range, shove their way up from the Yukon Territory in the southeast, where they join the Chugach Range in a torrent of glaciers and ice fields. The mighty Wrangell Range, coming down from the north, is the backbone of the park.

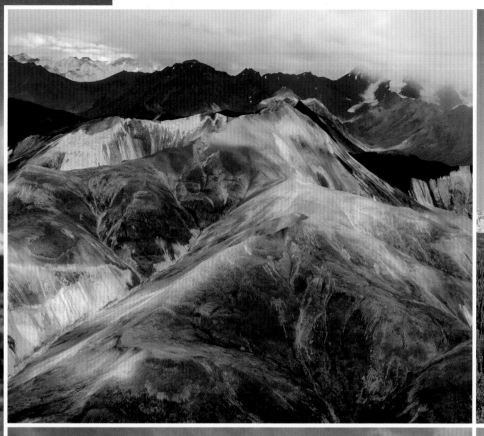

Wrangell–St. Elias is the largest national park: 20,587 square miles or more than 13 million acres. The park is six times the size of Yellowstone and larger than Switzerland. It has nine of the sixteen highest U.S. mountains—four of them are above 16,000 feet.

This rugged region has been called the Himalayas of North America. In fact, the rugged terrain of the park may actually be wilder than the great Asian mountains. There are still valleys in these mighty Alaskan mountains where people probably have never set foot, and countless peaks remain unnamed and unscaled. The park is so vast that it contains more unexplored terrain than the Himalayas, largely as a result of the short summers and long winters that come with its proximity to the Arctic.

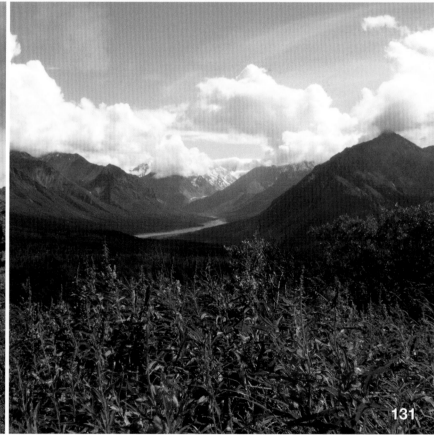

YELLOWSTONE NATIONAL PARK

Northwestern Wyoming, southern Montana, and eastern Idaho
Established March 1, 1872
3,468 square miles

Things to See: *Old Faithful; Roosevelt Arch; Mammoth Hot Springs; Yellowstone Lake; Bridge Bay; Fountain Paint Pot; Morning Glory Pool; Continental Divide*

Things to Do: *Hiking; Camping; Horseback riding and llama packing; Boating; Fishing; Bicycling; Cross-country skiing; Wildlife viewing*

Here on Earth, Yellowstone is as close to another planet as it gets. This alien landscape is home to more than half of the world's thermal features, an amazing variety of magma-powered plumbing that includes the archetypal thermal features of ferocious and majestic geysers, along with brilliantly hued hot pools, steaming fumaroles, and lethargically belching mud pots—about 10,000 in all, including more than 300 geysers.

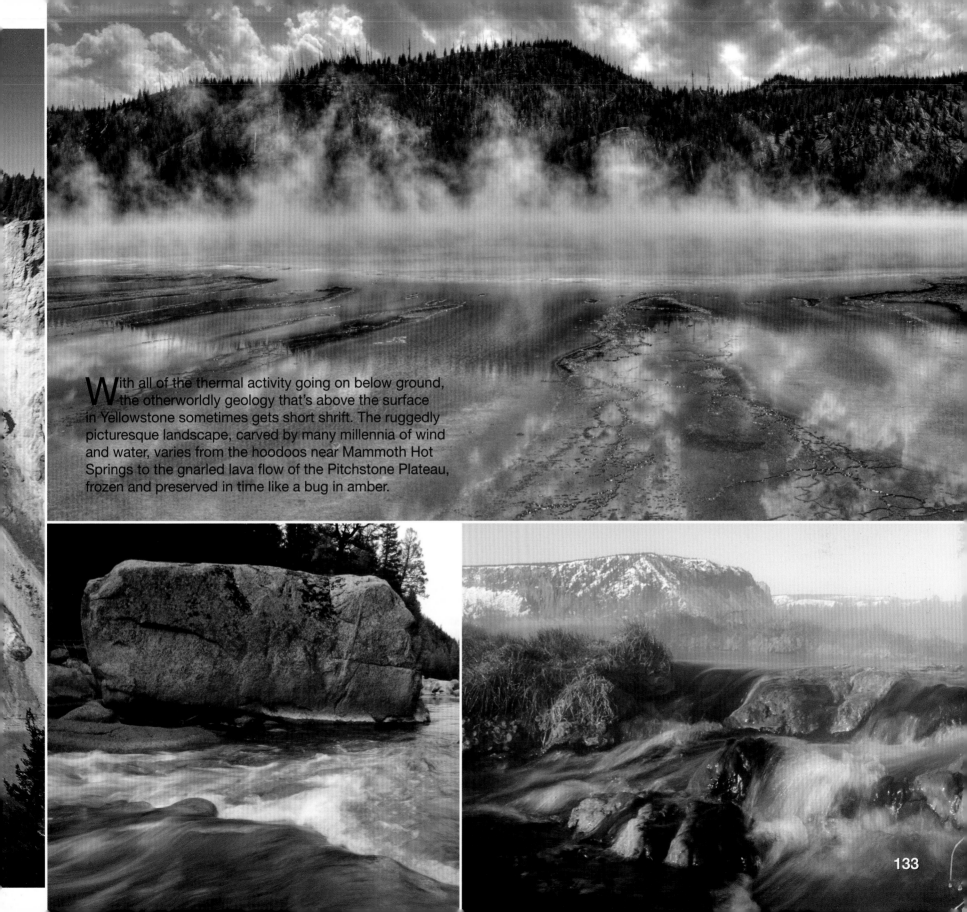

With all of the thermal activity going on below ground, the otherworldly geology that's above the surface in Yellowstone sometimes gets short shrift. The ruggedly picturesque landscape, carved by many millennia of wind and water, varies from the hoodoos near Mammoth Hot Springs to the gnarled lava flow of the Pitchstone Plateau, frozen and preserved in time like a bug in amber.

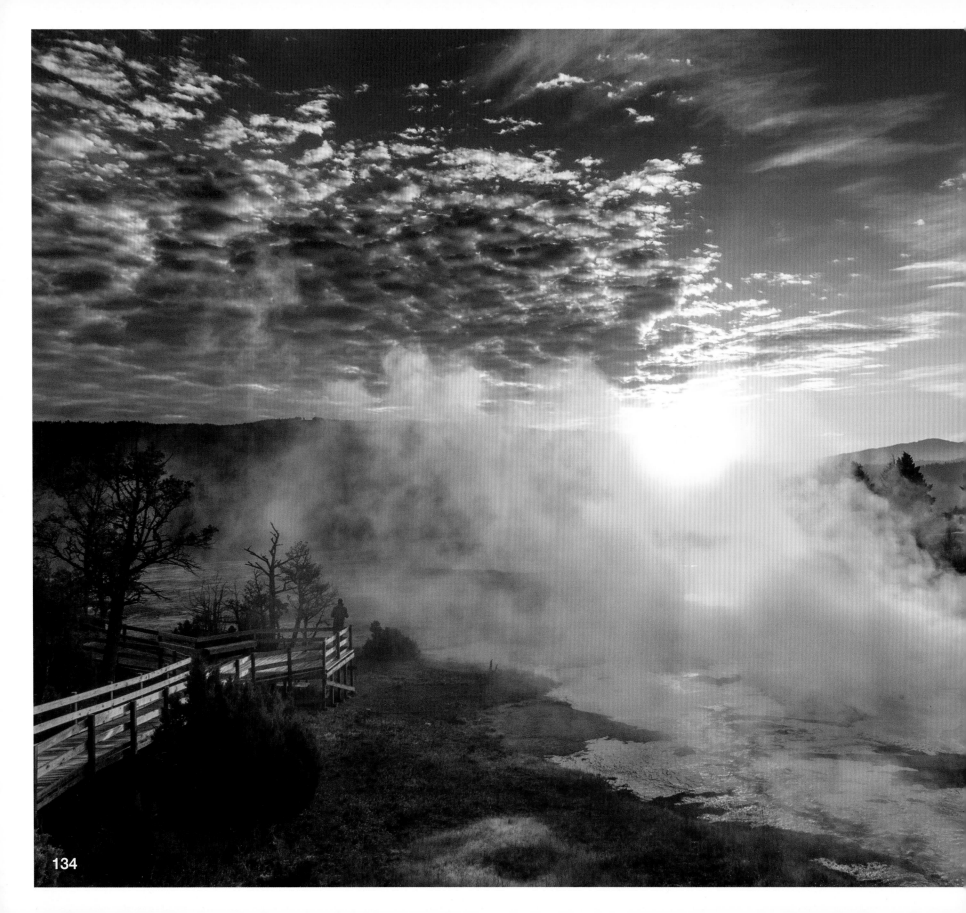

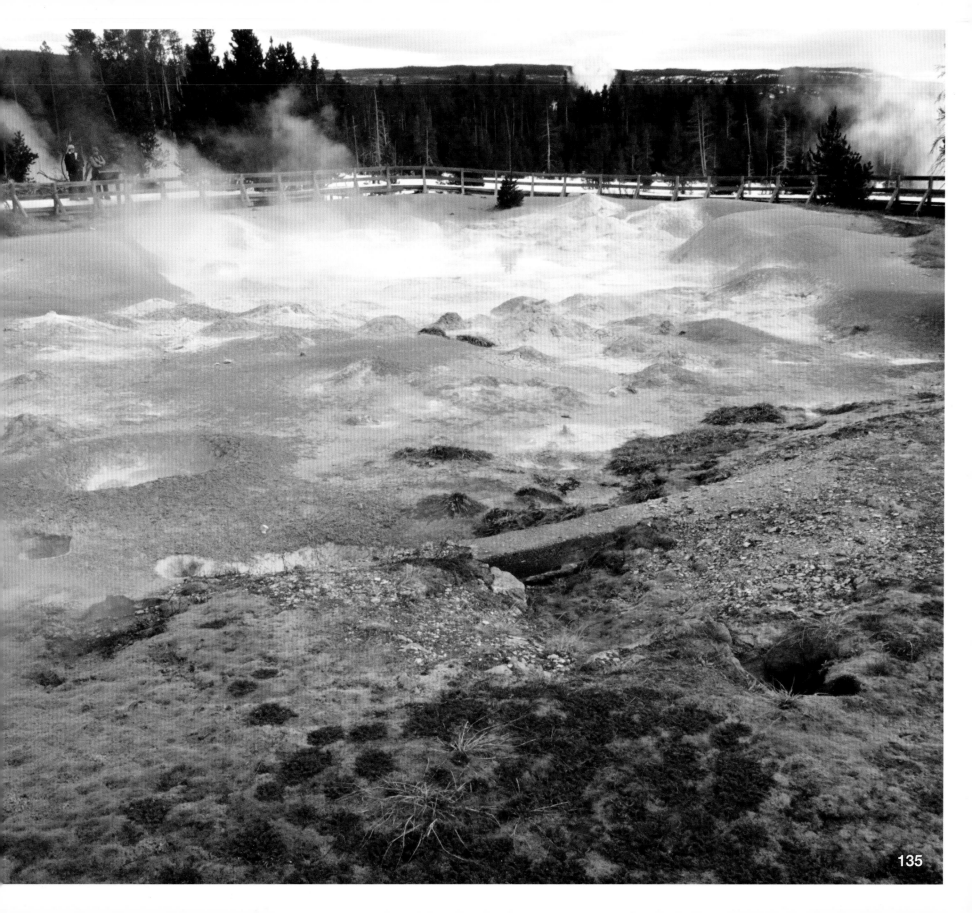

In 1872, the U.S. government designated Yellowstone the world's first official national park. That 1872 act has since inspired the creation of hundreds of national parks around the world. The first vacationers to the park came by railroad and rode stagecoaches to reach the interior and the grand lodgings at the lake and Old Faithful. In the Victorian era, this was not a trip for the masses; only the rich could afford these lavish vacations that often lasted a month or more. But the experience grew more democratic with the advent of the automobile in Yellowstone in 1916, and the number of visitors swelled to 100,000 by 1923.

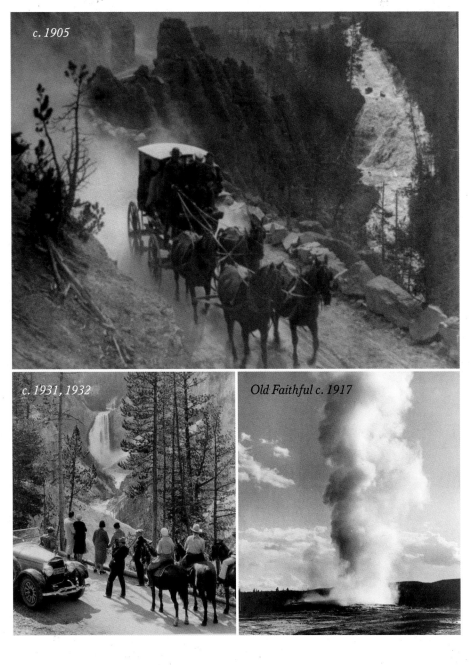

c. 1905

c. 1931, 1932

Old Faithful c. 1917

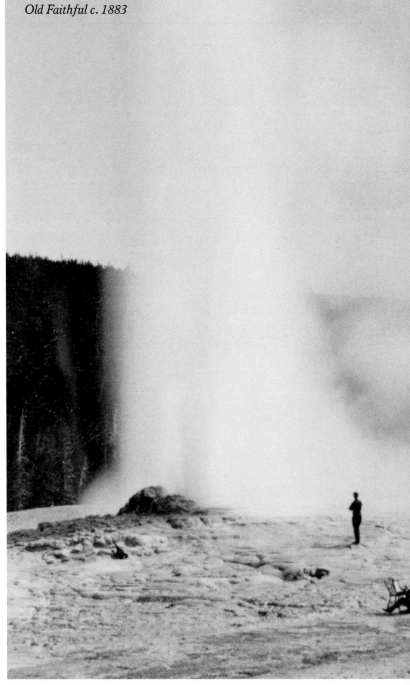

Old Faithful c. 1883

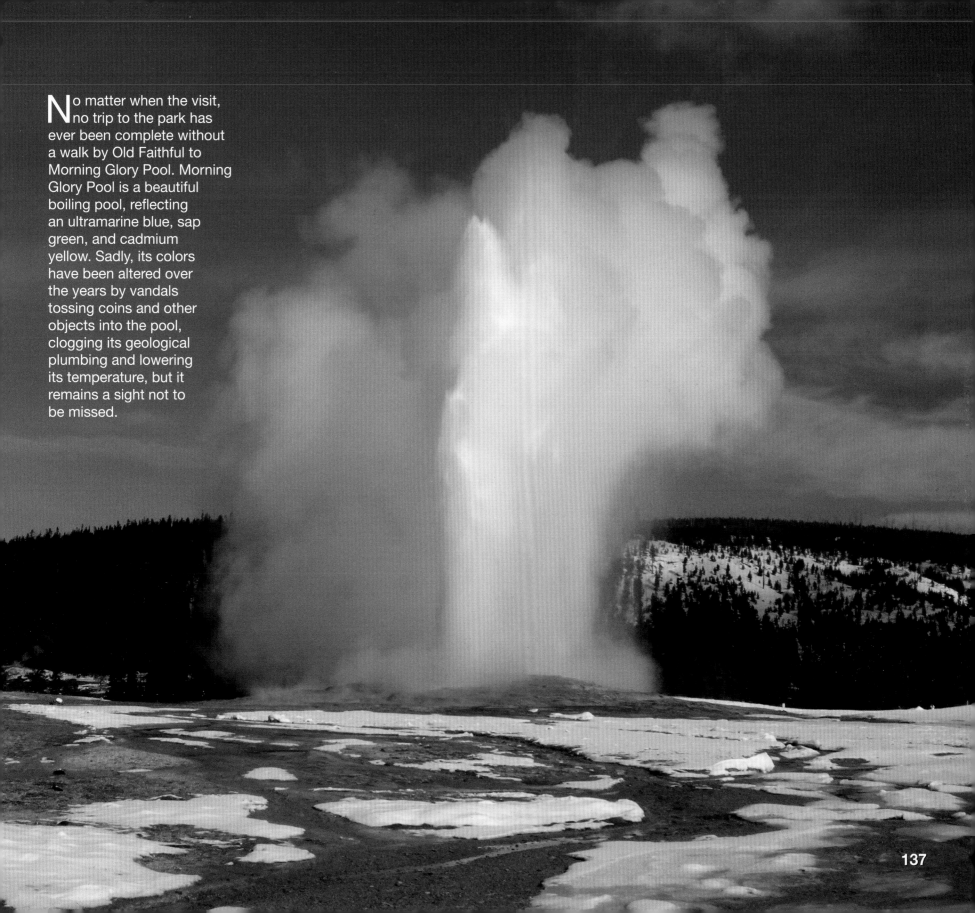

No matter when the visit, no trip to the park has ever been complete without a walk by Old Faithful to Morning Glory Pool. Morning Glory Pool is a beautiful boiling pool, reflecting an ultramarine blue, sap green, and cadmium yellow. Sadly, its colors have been altered over the years by vandals tossing coins and other objects into the pool, clogging its geological plumbing and lowering its temperature, but it remains a sight not to be missed.

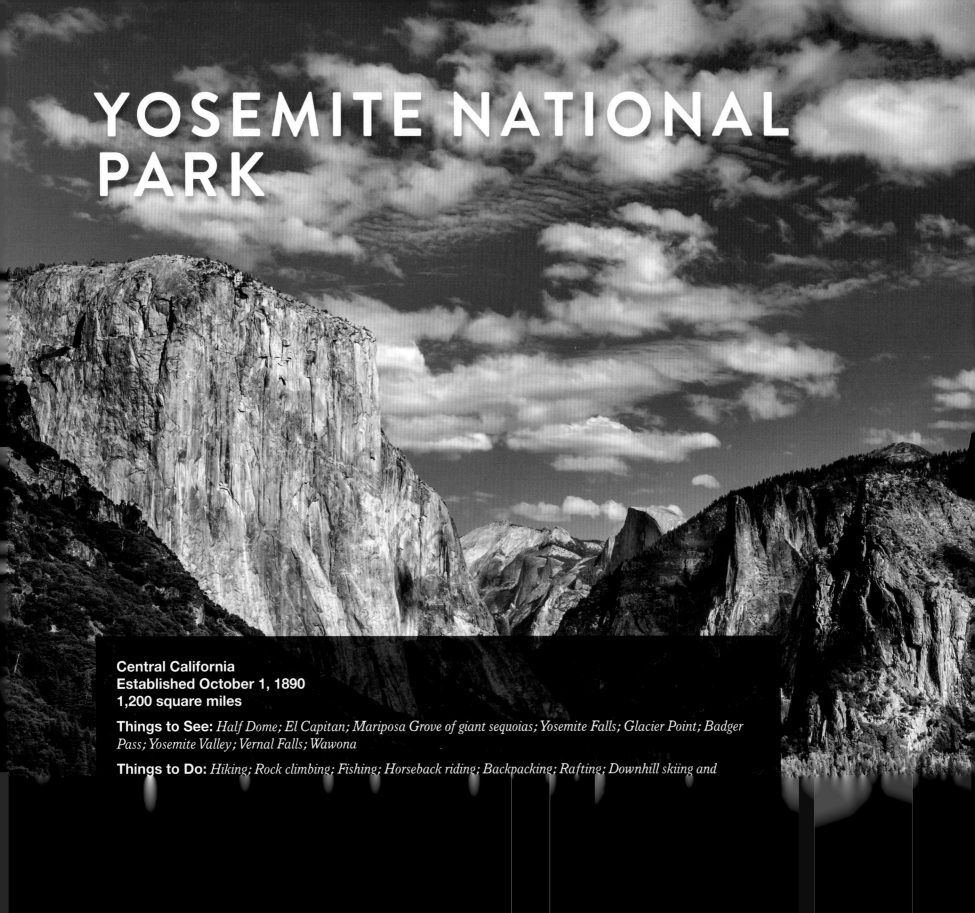

YOSEMITE NATIONAL PARK

Central California
Established October 1, 1890
1,200 square miles

Things to See: *Half Dome; El Capitan; Mariposa Grove of giant sequoias; Yosemite Falls; Glacier Point; Badger Pass; Yosemite Valley; Vernal Falls; Wawona*

Things to Do: *Hiking; Rock climbing; Fishing; Horseback riding; Backpacking; Rafting; Downhill skiing and*

Yosemite National Park is a showcase for the wonders of nature. This vast and varied domain includes giant sequoias, alpine meadows, peaks soaring above 13,000 feet, lovely alpine lakes, sparkling trout streams, grassy meadows, and glacial remnants. Within the park are four of the seven life zones found on the North American continent. The range of natural features is so diverse because of Yosemite's location in the temperate climate of central California and an unusually varied terrain, ranging from desert to high alpine.

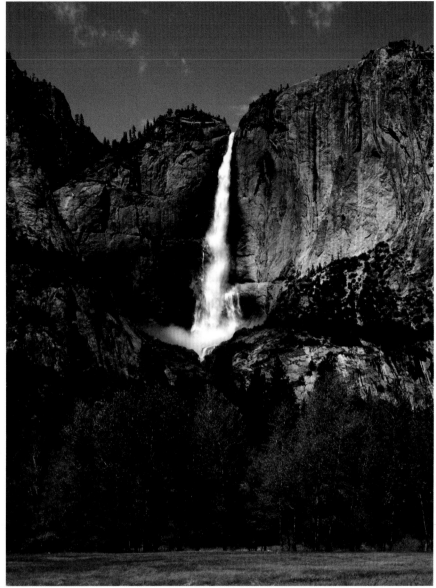

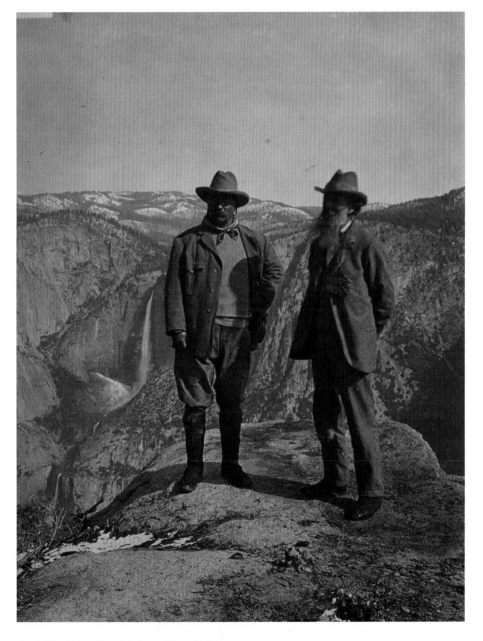

In his 1868 description of being at the brink of Yosemite Falls, John Muir lovingly depicted the panorama he saw from the meadows, perched above the tallest waterfall in North America. "The noble walls—sculptured into endless variety of domes and gables, spires and battlements and plain mural precipices—all a-tremble with the thunder tones of the falling water," he wrote. "The level bottom seemed to be dressed like a garden—sunny meadows here and there, and groves of pine or oak; the river of Mercy sweeping in majesty through the midst of them and flashing back the sunbeams."

139

The park's most famous landmark, Half Dome, with its great sheared-off face, rises 4,800 feet above the eastern end of the valley. El Capitan, a monolith that rises 3,600 feet above the evergreens along the Merced River, stands at the western entrance.

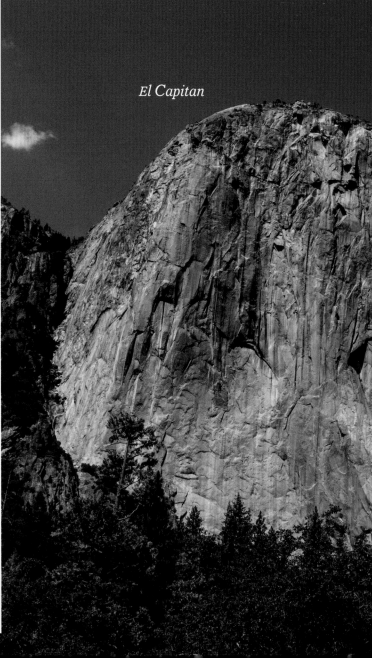

El Capitan

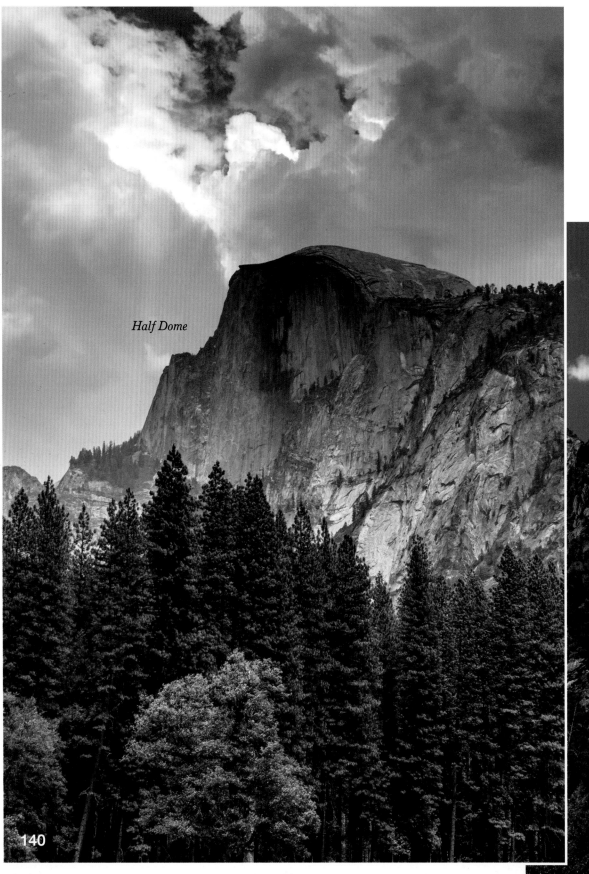

Half Dome

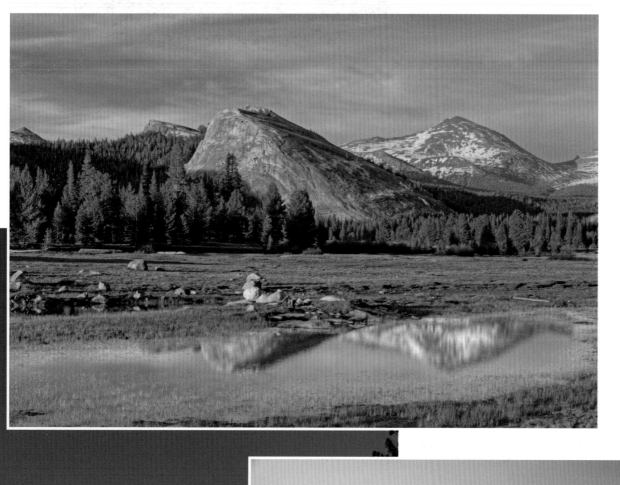

Where soil has been able to cover the rocky landscape, meadows appear, providing a habitat for such small animals as the marmot and pika. Dwarf willows and dozens of wildflower species dot the landscape. Tuolumne Meadows, one of the park's most cherished features, is a vast expanse of flowing grass, cut by the lovely Tuolumne River and circled by the snowcapped peaks of the Sierra.

141

ZION NATIONAL PARK

Southwestern Utah
Established November 19, 1919
229 square miles

Things to See: *Angels Landing; Emerald Pools Trail; Towers of the Virgin; Canyon Overlook Trail; Kolob Arch; Court of the Patriarchs; West Rim Trail; Zion Human History Museum*

Things to Do: *Hiking; Wildflower and fall colors viewing; Horseback riding; Camping; Bird-watching; Bicycling*

The first of the five national parks established in Utah, Zion National Park is centered on an awe-inspiringly beautiful network of chasms cut from a multihued block of sedimentary sandstone, dominated by wind- and water-carved rock formations of every size, shape, and description.

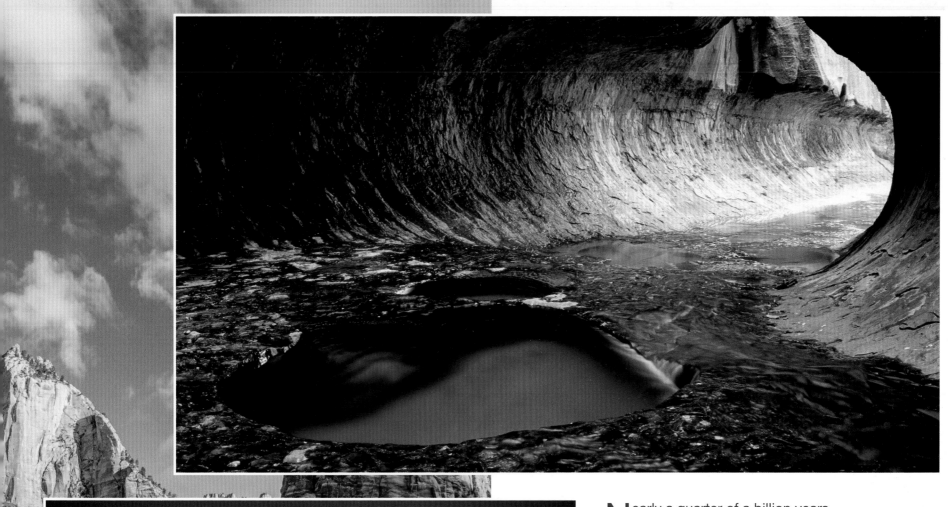

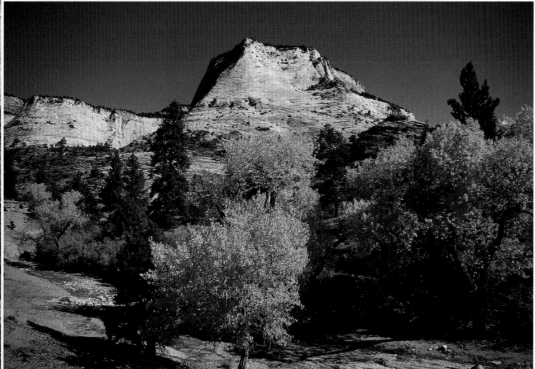

Nearly a quarter of a billion years ago, the area that is now Zion was a mostly flat expanse of land. Over the millennia, streams carried layer after layer of sediment down from the surrounding mountains. In the process of adding 10,000 feet of rock on top of the former surface, this sediment weighed down the crust, and the land sank under the stress of its new crown, buckling the landscape. This phenomenon made Zion the last step on the immense swath of geology known as the Grand Staircase, stretching from the Grand Canyon in Arizona through Bryce Canyon to Zion. In fact, the bottom layer of Zion is geologically the same as the top layer at the Grand Canyon.

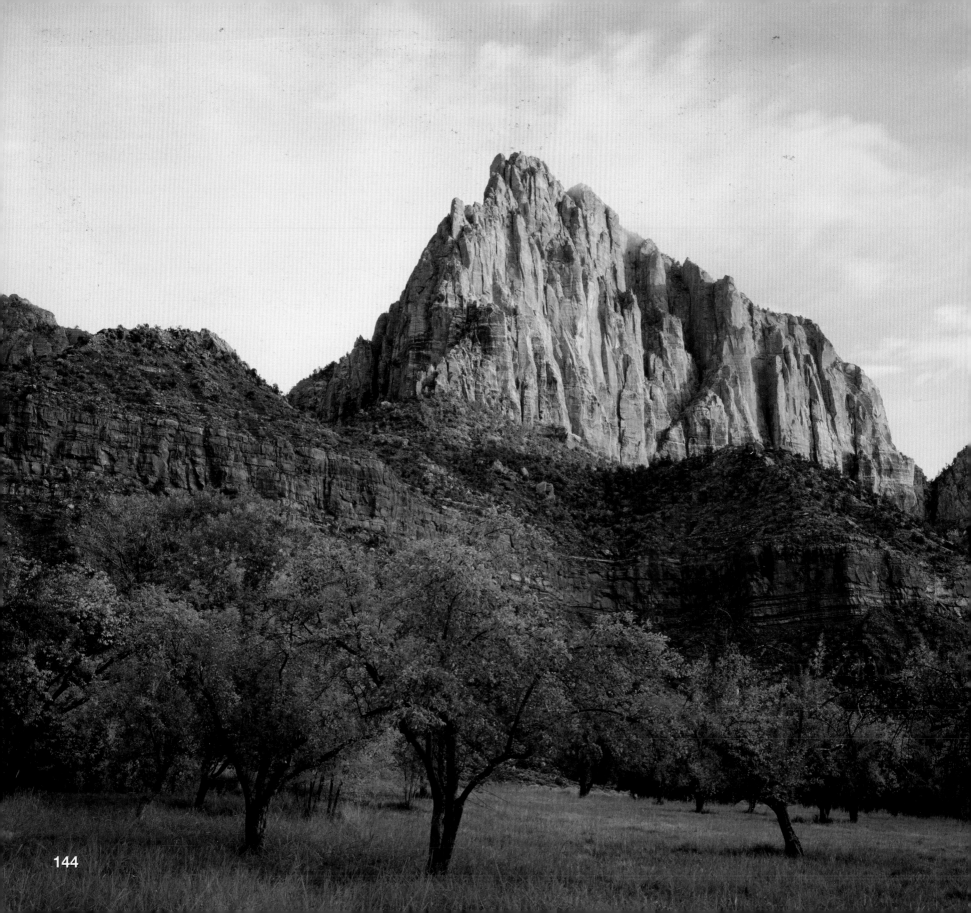